COPYART

The first complete guide to the copy machine

Designed by Mike Firpo

COPYART
The first complete guide to the copy machine

Created by Patrick Firpo, Lester Alexander, and Claudia Katayanagi

Opening text written by Steve Ditlea

Produced by Horseguard Lane Productions, Ltd.

for

 Richard Marek Publishers, New York

Special thanks to

Sonia Landy Sheridan, Diane Kirkpatrick, Tyler James Hoare, Dr. Douglas Dybvig, Don Conlin, Chris Gray, Judith Hoffberg, Charlton Burch, Peter Thompson, Craig Goldwyn, Linton Godown, Robert Gundlach, Joe Battle, Kirsten Hawthorne, Kathy Whelan, Sandy Garvin, Lisa Collier, Michael Rudell, Lynn Smith, James Kennedy, William Peter, Anita Halder, Ann Knauerhase, Mike Firpo, and the more than 160 artists who contributed work towards this book, and last, but not least, Joyce Engelson and Richard Marek, without whose support none of this would have been possible.

and a very special thanks to

Jack and Denise Firpo, Natalie Katayanagi and Alex Alexander who never lost faith.

Library of Congress Cataloging in Publication Data

Main entry under title:

Copy art.

 Bibliography: p.
 1. Copy art—United States—Addresses, essays, lectures. I. Firpo,
 Patrick.
 Ne3000.C66 760 78-15827
 ISBN 0-399-90016-0

Printed in the United States of America

First printing

TABLE OF CONTENTS

PREFACE

In the following 160 pages you will be introduced to the copy machine. You will discover beyond its function as an "office tool", the copier has, for many people, become a means of self-expression. *Copy Art* introduces you to a new art form, opening doorways to a myriad of interesting and creative possibilities.

To many people, technological tools present a facade of cool intimidation. They sit, daring you to touch them. *Copy Art* attempts to erase this fear of machines and encourages everyone to befriend their local copier.

You will find represented here more than seventy artists, artisans, craftsmen and hobbyists who have discovered that the copy machine can do a whole lot more than *just* make copies.

We have divided this book, in an attempt at clarity, into three sections.

The first section deals with the history of the copy machine. It will give you a little background information on what and who you are dealing with, where the copier came from, and how it works.

The second section, "COPY ART", illustrates the creative contributions, comments, techniques, and applications of people exploring this medium.

The final section, "COPY CRAFTS", will hopefully inspire you to take a plunge and *see* what you can come up with on the copy machine. "COPY CRAFTS" covers only a partial list of uses for these versatile machines. Your imagination and experimentation will create the rest.

In some strange and mysterious way, the copier is a "magical machine." You will find that very often the "accident", the "unplanned", and the "unexpected" will produce results you could not even begin to imagine. There is little doubt that copiers are here to stay. The question is, what will they do next?

INTRODUCTION

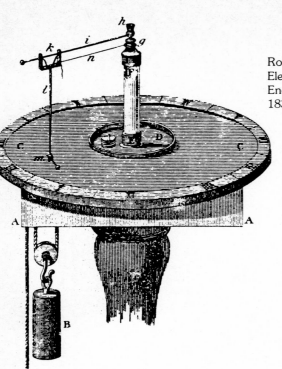

Ronald's *"Electrograph"*, Possibly the First Electrostatic Recording Apparatus ever built. (from Encyclopaedia Britannica, 7th Edition, published 1830-1843.)

INSTANT ART FOR EVERYONE

Welcome to the age of *Copy Art*. Now anyone has the potential to be an artist or designer at the push of a button. That office copying machine you may take for granted happens to be no less than an instant image-making tool. A dream of artists for centuries, it's yours to use for just pennies per copy.

With some 3 million copying machines in the United States today, an artists' print shop is only as far as your local library, post office, or quick copy center. Copies are more and more easily available and continue to defy inflation; after years of shrinking in price, they are still getting cheaper. Improved image quality, permanence, and full-color capability have also made instant copying attractive as a personal crafts medium.

Thanks to modern technology, copy art may well be the most democratic and spontaneous art form of our time. No special training or exotic materials—aside from the copier itself—are required to give anyone's imagination free rein. Because it can create instantaneous images, the copier is truly the "great American vision machine."

To some, *copy art* may sound like a contradiction; art has to be original, they've been told, so how can a copy be a work of art? According to the *Oxford English Dictionary* the word *copy* means both "a transcript or reproduction of an original" *and* "the original writing, work of art, etc. from which a copy is made."

As for *art*, among several definitions, *Webster's Dictionary* offers the following: "the conscious use of skill, taste and creative imagination in the practical definition or production of beauty."

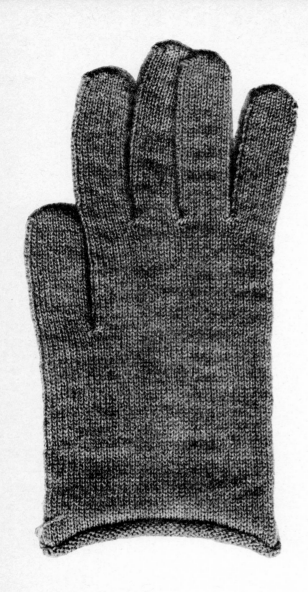

Les Levine

"Glove Mudra"

1978, 3M Black and White Copier, 10" × 14".

"In order to use copying machines to make art, three things are absolutely necessary. The first is crazy wisdom. The second is fearless compassion and the third is a magic dagger which should be plunged into the brain one second before the button on the copying machine is pressed. If all these three rules are adhered to, a perfect work of art will result."

It took photography almost a century to be recognized as a legitimate art form. With copier technology publicly introduced little more than a quarter-century ago, how long before copy art is accorded the respect of the Art Establishment? Judging from serious interest on the part of artists, museums, and schools, it could be a lot sooner than you might expect.

Pop painter Larry Rivers, as well as avant-gardists Stan Vanderbeek, Aldo Tambellini and Les Levine have all turned to copiers for immediacy in creating their art.

Tyler James Hoare of San Francisco made his first piece of copy art by accident in 1965. Since then his works have been shown at the Oakland Museum, the Albany, N.Y. State Galleries, and Harvard University. "At museums and universities," he reports, "you'll find them receptive to works done on a copier in photography, painting, or sculpture departments. Never in printmaking, though; using a copying machine is antithetical to trained print makers." Still, his copy pieces are especially appreciated in print shows. "Juries get tired of seeing hundreds of etchings and woodcuts. They find the copy works especially the color ones, refreshing."

Sonia Landy Sheridan began teaching the first course in the use of copiers at the School of the Art Institute of Chicago in 1970. Today there are dozens of similar courses being given in art schools and universities across the country. Sonia Sheridan refers to copy machines as "generative systems," to emphasize their creative potential as art tools. Since 1971 her Generative Systems Department has offered a Masters degree program in copy art at the Institute.

Stan Vanderbeek

"Animation Frame"

1977, Computer Animated Film Frame, 7¼" × 7¼".

A charming woman in her early fifties, Sonia Sheridan views artists' involvement with the copier as part of a wider contemporary movement: "We live in an era when art and science are coming together after having been split since the Renaissance. Da Vinci would have had no problem with using a copier for art."

The copier is one path towards the art of the future, according to Sheridan: "We will be living in a technological society. There is no turning back. We will be governed and conditioned by scientifically produced technological tools. How can the artist ignore these tools and still participate in general human enlightment? What alternate route can the artist travel?"

A lifelong populist, she stresses the copier's societal impact. "We all know how the secret of writing was removed from the exclusive realm of the priests when the printing press was invented. We are now witnessing the reappearance of image-making as a human endeavor, made possible by the instant imaging technology."

The office copier's ease of operation has certainly made it the most accessible imaging tool this side of the instamatic camera. With no exposure settings or special controls to worry about, a usable print is just a push-button away. At the same time this very simplicity can be frustrating, should an artist want control over the image-making process to insure the best quality reproduction possible.

A photographer can always move up from an instamatic to a more sophisticated camera, with dials and settings designed to make it a flexible tool. The copy artist can only wish for such options. Most copier manufacturers try to engineer out any possible variables and discourage

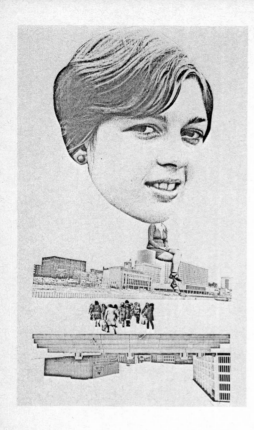

Joel Swartz

From, *"Downtown: A Young Woman's Plight"*

1975, Haloid Xerox Flatplate, 8″ × 10½″.

tampering with their machines' innards by an elaborate series of electrical interlocks.

The search for greater control over the copy process has led some artists to go outside the copying machine altogether, while still using its basic principles. In her recent landmark exhibition at Chicago's Museum of Science and Industry, "Energized Artscience: Patterns in Motion," which drew as many as 65,000 visitors a day, Sonia Sheridan let the public try out several copying systems, including one consisting of a fur mitten, a sheet of plexiglass, a light bulb, carbon black, and a stove. In the show's catalogue she provided lessons on do-it-yourself non-machine copying.

In trying to exercise control over their chosen medium, other artists like Joel Swartz and Craig Goldwyn have returned to early copier models—like Xerox's first office machine the "Standard Camera #4," a huge gray hulk which requires over a dozen separate operations by hand to complete a single copy.

While such experiments may yield excellent results, they lack the immediate gratification which is at the heart of the copying machine's appeal. In a world of instant coffee, instant movies, and instant lotteries, the copier offers instant creativity—within limitations. Some of these limitations are inherent in the copy processes themselves; others are the result of seemingly arbitrary business and marketing decisions by copier manufacturers.

In 1968 the 3-M Corporation of St. Paul, Minnesota, trailing badly in the black and white copier field, announced the world's first commercial instant color copying system. The Color-In-Color machine was a dramatic breakthrough: in 30 seconds it could produce a high-quality

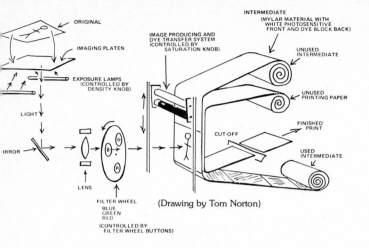

ORIGINAL

IMAGING PLATEN

IMAGE PRODUCING AND
DYE TRANSFER SYSTEM
(CONTROLLED BY
SATURATION KNOB)

INTERMEDIATE
(MYLAR MATERIAL WITH
WHITE PHOTOSENSITIVE
FRONT AND DYE BLOCK BACK)

UNUSED
INTERMEDIATE

EXPOSURE LAMPS
(CONTROLLED BY
DENSITY KNOB)

UNUSED
PRINTING PAPER

LIGHT

FINISHED
PRINT

CUT-OFF

MIRROR

USED
INTERMEDIATE

LENS

FILTER WHEEL
BLUE
GREEN
RED
(CONTROLLED BY
FILTER WHEEL BUTTONS)

(Drawing by Tom Norton)

3 M Color-in-Color Copier I

8½ by 11 inch full color dry copy. Don Conlin, the copier's project manager, wanted to explore the Color-In-Color copier's graphic arts possibilities, so he took the unusual step of inviting Sonia Landy Sheridan to work with 3-M as artist-in-residence.

Assured the fullest cooperation of company engineers, Sheridan tried to render the Color-In-Color machine more flexible for artists' use. Soon the color copier was truly interactive, allowing its operator to alter color relationships, values, and density at will. The machine could now serve as a time-saving tool in design and commercial arts applications.

In 1973, Xerox, the heavyweight of copier firms, announced its entry into the color copier market with its Model 6500. Designed for the reproduction of bar charts, pie charts and accountants' red ink, the 6500 was never meant to be an artistic tool. It took Xerox management by surprise when iron-ons and T-shirts provided significant initial demand for the 6500's capabilities.

By most accounts—including those of Xerox engineers—3-M's Color-In-Color machine produced the best results—pastel-like colors with excellent saturation. The Xerox machine's color was muddy by comparison: its black often an unconvincing dull green. What the 6500 gained in sharpness was easily surpassed by Color-In-Color's flexibility. Yet by 1975 3M had to stop distributing the Color-In-Color machine. For all of its advantages, Color-In-Color was simply undone by the bottom line: Xerox could turn out a color copy for 2/3 the cost of 3M's process. Though perhaps a less desirable machine, the 6500 gained a virtual monopoly over color copying for years to come.

Far from being discouraged by her experience at 3-M, Sonia Sheridan feels that artists and the copier industry will benefit from further cooperation. "The artist who is prepared to empathize with industrial problems will not only gain by a shift in attitude, but will make the relationship feasible. Industry must in turn recognize the need for the artist as inventor, creator of new markets and generator of ideas."

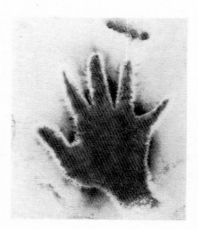

Sonia Sheridan's handprint was reproduced without a copier by rubbing a piece of plexiglas, exposing it to light and sprinkling with carbon black.

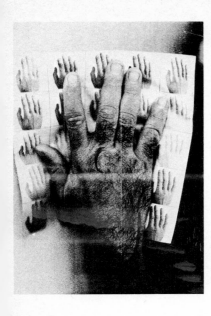

Paulo Bruscky

Untitled

1977, 3M Black and White, 8¼″ × 12½″.

IT'S A COPY COPY WORLD

There are nearly 200,000 born every minute; a total of 100 billion instant copies produced each year in the United States alone. Xerox estimates that the information kept by American business increases every year "at the rate of 4,000 documents—or nearly one file drawer—per white collar employee per year." (As a test, a Boston firm recently stamped on all office copies: "Did you really read this?" Over half the returned copies were marked "no.") Add to this the paper clone mania of federal, state, and local bureaucracies and it is easy to see why office copiers continue to proliferate as fast as the copies they produce.

The copier industry may have been born in the U.S., but the copy craze now extends worldwide. In the U.S.S.R., for instance, the central government planning office reproduces its documents on Xerox machines. World consumption of instant copies has grown fivefold since 1970. Today worldwide revenues for the copier industry are close to the $8 billion mark— *surpassing world income totals for movies or the record industry.*

The copying machine has already altered the course of world history. Without a copier, Daniel Ellsberg might never have been able to leak the Pentagon Papers and for all we know the U.S. might still be entangled in a war in Southeast Asia.

To alarmists who insist on seeing the copier as a bureaucratic tool used in violating citizens' privacy, it should be pointed out that the copier has also resulted in government becoming less secretive and more responsive to the public.

Major disclosures about C.I.A. and F.B.I. misconduct and subsequent reforms were the result of copies of documents leaked to the press. It is ironic that back in 1950, the C.I.A.

bought the world's first commercial dry copying machine, the Thermo-Fax, pioneered by 3-M. Today the Freedom of Information law—by which anyone can request copies of U.S. government records, including the C.I.A.'s—would be impossible to implement without the instant copier.

Befitting its importance in American society, the copier is subject to an ever-growing web of legislation. As copy machine key operators are constantly being reminded, in addition to officially classified documents, it is illegal to copy a whole list of materials, including veterans' discharge papers, naturalization or immigration documents, draft cards, military I.D.'s, stock and bond certificates, Treasury notes, paper money, postal money orders, stamps, and U.S. passports. In addition, many states prohibit the copying of automobile registrations and drivers' licenses. To thwart illegal copying and fraud, special paper coatings have been developed, as well as fluorescent inks which glow brightly when subjected to direct light, making copier reproduction difficult.

A troublesome area for copier users is the question of copyright law. According to Marshall McLuhan, "Xerox has enabled all men to become publishers". Where does freedom of the press as set out by the U.S. Constitution encroach upon author's rights defined by copyright legislation? A recent overhaul of the copyright law has yet to be tested through the courts, so there remains some doubt as to what constitutes "fair use" of copies made from copyrighted material.

Copying a small portion of a work for personal use may not deprive an author or artist of potential income, but cases like that of a teacher dispensing copies of a class reading to his students have become grist for the legal mill. In order to avoid any possible liability, the copying services of New York's Public Library at 42nd Street and Fifth Avenue now require a

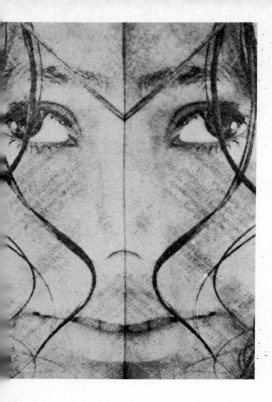

Tyler James Hoare's early copy art works made use of the symmetries inherent in the Thermo-Fax process.

disclaimer be signed and every copy they make bears the warning, "THIS MATERIAL MAY BE PROTECTED BY THE COPYRIGHT LAW (TITLE 17, U.S. CODE)." The New York Public Library, incidentally, is where the inventor of xerography first went to research his idea for a copying machine.

In the related area of trademarks, the Xerox Corporation has over the years run ads to assert its rights to the word derived from the Greek *Xeros*, meaning "dry" (as in dry copier). Claim the Xerox lawyers: "The Xerox trade name and trademark are among the most valuable assets we have . . . If through popular misuse, the word Xerox is generally adopted as the common name or generic term for something, it can lose its unique value as has already happened with once valuable trademarks such as aspirin, mimeograph, escalator, and others."

Desired usage according to Xerox includes the following: "The Xerox trademark is always used as a proper adjective. It should never be used alone as a product name but should be *followed* by the common name of the product such as Xerox *copier* or Xerox *duplicator*. (There is no such thing as a "Xerox".) The word Xerox should not be used to *describe* anything. It is not a substitute for descriptive words such as 'xerographic' or 'electrostatic'. Please say 'a xerographic copy', not 'a Xerox copy'. Also, the Xerox trademark cannot properly be used in the *possessive*, as in 'Xerox's speed'; in the *plural*, as in "We have many Xeroxes'; or as a *verb* such as 'Xerox it.'" In a cartoon illustrated brochure, they sum it up this way: "So please: *copy* things, don't 'Xerox' them. Make *copies*, not 'Xeroxes'. On the *Xerox copier*, not 'the Xerox.'"

It should be noted that Thomas Edison once valued as one of his greatest assets the Mazda trademark on lightbulbs. When was the last time somebody asked you to turn on a

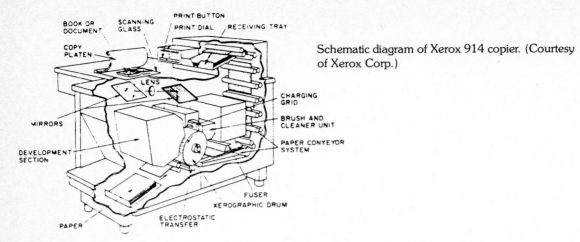

Schematic diagram of Xerox 914 copier. (Courtesy of Xerox Corp.)

Mazda?

A few years ago, when the Xerox Corporation controlled 95% of the office copier market, Xerox virtually became synonymous with instant copies. These days, due to fierce competition, the company's share of the world copier market is 60% and falling. Meanwhile however, the Xerox Corporation remains one of the great business successes of modern America. Once the modest Haloid Company of Rochester, N.Y., its acquisition of inventor Chester Carlson's patents for electrostatic copying soon made Xerox a regular in the top reaches of *Fortune* magazine's annual listing of the 500 largest U.S. corporations. When Xerox introduced its model 914, the first practical plain paper office copier in 1960, Xerox's revenues amounted to $35 million. In 1977, Xerox profits totaled $406 million on total revenues of $5 billion.

Stories of early Xerox stockholders becoming wealthy off their modest investments are now part of Wall Street folklore. Stockbrokers love to tell about the Rochester taxi driver who bought one hundred shares of Haloid stock at ten dollars a share—against his friends' advice. With his stock splitting 180 times in the next two decades, the former cabbie's thousand-dollar investment became worth over one million dollars!

Today Xerox is by far the biggest copier firm in the world. Through subsidiaries in England, Japan, and Latin America, Xerox products are available in 113 countries. In the U.S. alone, Xerox has one million copiers in the field and employs a sales and service force of 45,000 people. Xerox has tried to diversify into other areas of the information business, including an unsuccessful foray into the computer field, and a library services division which has made Xerox the second largest publisher of educational materials in the world. Despite efforts to gain a wider economic base, over 90% of Xerox revenues still come from the copier business. Copies should continue to be Xerox's most important product through the 1980's.

One of the secrets of the company's success in copiers has always been its aggressive

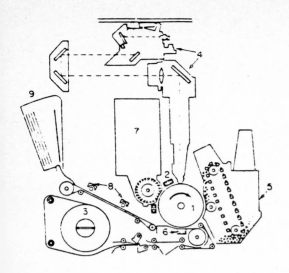

Process diagram of IBM Copier II.
(1) Photoconductive drum, (2) corona charger,
(3) paper supply roll, (4) optical system,
(5) developing unit, (6) transfer corona,
(7) cleaning unit, (8) heat fusing units, (9) stacking
bin. (Courtesy: The International Business
Machines Corporation.)

sales policy, which starts with the sales and service personnel—affectionately known as "Xeroids"—recruited by local managers. As *Fortune* once remarked, "they are ambitious, impatient, self-confident, aggressive, and competitive to a degree that one amused manager labels 'bloodthirsty.'" New recruits are subjected to eight months of training in the Xerox cult of sales—with up to a fifteen-week stint at a company training campus in Leesburg, Virginia—referred to as "Copier College."

Once they are unleashed on the general populace, Xerox sales people are given the grueling task of canvassing businesses for new accounts. Over half of a Xeroid's income comes from outselling a quota set according to past revenues in a territory. Since most Xerox machines are leased to customers, sales people are regarded as responsible for preventing their accounts from switching to other brands of copiers. A fine equal to the original sales commission is deducted from their paychecks—even if the commission went to a predecessor in that territory. Is it any wonder Xeroids try harder?

Since 1970, Xerox has seen its dominance of the office copier market eroded by heavy competition, in what have been called the *Copier Wars*. Not as epic in scale as *Star Wars*, the *Copier Wars* are nonetheless filled with the drama of multi-million dollar gambles in the nation's second largest business—the information industry. The largest industry is still energy and now the Exxon Corporation has become Xerox's latest direct competitor in automated office machines and word processing systems.

But Xerox's mightiest competition in copiers has come from the behemoth I.B.M. Corporation. In the past decade, the world's biggest computer manufacturer has also produced three quick and economical plain paper copiers. I.B.M.'s Copier II is said to have displaced over 20,000 Xerox machines. In retaliation, Xerox has brought a patent infringement suit against

I.B.M., claiming the computer firm had abused a licensing agreement between the two giant companies. In the courts for many years, it's one of those cases which will pay off the mortgage on many a young lawyer's new home.

On the technological front, Xerox has had to face the challenge of Kodak's innovative "third-generation" copiers, which include computer microprocessors capable of diagnosing breakdowns and controlling the many copying variables for what some feel are among the best quality black and white instant copies available today. In the area of coated paper copying techniques, the 3M Corporation holds a significant lead.

As for so-called slow copiers, machines which turn out between eight and twenty copies a minute (a high speed copier can produce 120 per minute), Japanese manufacturers have made serious inroads against Xerox desk models. In three short years, Xerox's Japanese competitors have increased their yearly output from 79,000 to 385,000 plain paper copiers.

Intense competition has lowered copy prices and opened up a larger market than anyone could have expected only a few years ago. It has also broadened applications for the instant copier. The graphic arts are but one important frontier. With its models 9200 and 9400, Xerox is trying to make quick copies competitive with offset duplicating systems. Xerox scientist Robert Gundlach foresees improved xerographic reproduction bringing the day of instant book publishing: "It will make possible *demand publishing*, with the ability to print a copy of a book on the spot—from a microfiche *the size of a playing card*."

Other copier visionaries predict such marvels as instant copies of what a person sees, shot directly off the back of the *eye's retina*. More hard-nosed are predictions that all photographic print processes will be gradually replaced by instant copy technology. This is fitting, since the modern office copier began as a modest attempt at replacing slow, messy photographic copying systems.

Then, like Xerox, it just grew . . .

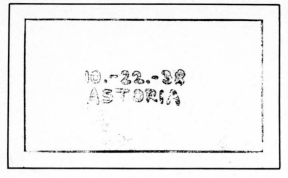

The world's first instant dry copy.
Courtesy Xerox Corporation

OBSESSION IS
THE MOTHER OF INVENTION

10.—22.—38 ASTORIA. It may not seem like an earthshaking message, but it is every bit as important to the saga of modern communications as Samuel Morse's telegraphic "What Hath God Wrought?" and Alexander Graham Bell's first telephoned words, "Mr. Watson, come here, I want you!"

On October 22, 1938, in an apartment in the New York City bedroom community of Astoria, part-time inventor Chester F. Carlson and an assistant produced the world's first copy with the electrostatic process, or as it was later to be known, xerography.

Chester Carlson embarked on creating his dry copier in 1935. It was 1947 before he would receive any royalties from his invention. All those years of trying to sell industry on the usefulness of his instant copy process cost Carlson his marriage, his health, and just about every spare cent he earned at his job as a patent attorney. When the payoff finally came, Carlson's copying obsession made him a multimillionaire, though he retained the modest tastes of his less prosperous days.

Carlson sounds like the mythic American inventor, a Horatio Alger hero, as portrayed by Don Ameche in a Hollywood movie of the 1930's. If they still made pictures like that, today they might get George C. Scott or Paul Newman to play the part of the long-suffering Chester Carlson. They'd probably call it something snappy like "The Astoria Wiz" . . .

When our story opens, at the age of fourteen Chester has become the sole support of his family. He gets up at dawn to wash store windows. Then it's out to the ramshackle schoolhouse where at times he is the only student. After school he is employed as a janitor in a

newspaper office. On Saturdays, he works from six to six.

Chester's mother dies when he is 17. With his ailing father to support and care for, Chester still manages to put himself through college—first at a junior college in Riverside and then at the California Institute of Technology, where he receives his B.S. in Physics.

The year is 1930 and the Great Depression has swept the nation. Carlson writes to over eighty companies in search of a job; he receives two replies and no job. Now $1400 in debt, he moves to New York City and lands a job with the Bell Telephone Laboratories. As the Depression worsens, Carlson is laid off by Bell Labs. He finds another position, then is hired as a patent specialist by the P.R. Mallory Company. With the earnings from this job Carlson will finance his research into xerography.

Both at work, where he has to copy patent applications, and during his off-hours, when he is busy studying law out of library books which he copies methodically by hand, Chester Carlson wonders why no one has ever invented a fast, simple, economical copying system. There are photochemical copiers around, of course, but the making of a photostat is a skilled operation usually confined to large offices and the blueprint and whiteprint (diazo) methods are mainly used for special copying. Carlson thinks he can come up with something better.

Realizing that major companies have already staked out photochemical processes, he decides to look elsewhere. He goes to the library and starts investigating other branches of technology. He zeros in on what he initially calls "electrophotography."

In theory, copying writing on a piece of paper shouldn't be especially difficult; all that is

Lichtenberg Powder Figure, produced by C. F. Carlson.

Courtesy Xerox Corporation

needed is a way to convert a pattern of dark (print) and light (paper) on one surface into an identical pattern on another surface. Carlson's idea is to create images by using static electricity, the same invisible force which creates sparks at your fingertips in wintertime and causes a child's balloon to cling to a wall.

The effects of static electricity were known in ancient China and Plato's Greece, though it wasn't until 1777 A.D. that German physicist George Christoph Lichtenberg produced the first electrostatic visual recording by causing a spark to form a treelike branching pattern in a layer of powder. Still later, the experiments of Hungarian physicist Paul Selenyi through the 1920's and 1930's, using early versions of the television cathode-ray tube for printing images help convince Chester Carlson that he is on the right track.

While still working at his job and studying law, Chester starts experimenting with various materials in his apartment. In a scene Hollywood would be proud of, Chester spills some chemicals, sending a stench through the entire building, and the landlady's daughter knocks at his door to investigate. Chester tells her about his idea for an office copier. They fall in love and are soon married.

The umpteenth time Chester spills chemicals all over the stove and nearly burns the house down, his wife banishes him to a vacant apartment in a building her mother owns in Astoria. He hires a lab assistant, a German refugee named Otto Kornei, to help him build his dream machine. Carlson works hard, fearing that the arthritis he now suffers from in his back may eventually cripple him.

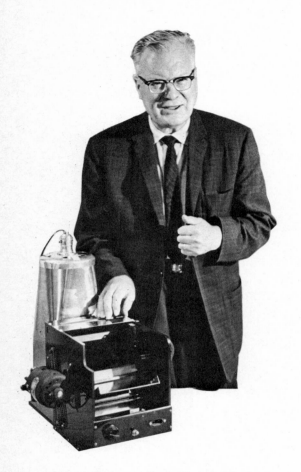

Chester Carlson, with the first model of his instant copier.

On a chilly October morning, Carlson and Kornei discover the combination of materials they've been looking for. First Carlson rubs a cotton handkerchief across the surface of a metal plate coated with sulphur; this charges the plate with static electricity. Then he puts a glass slide bearing the date and location over the plate and shines a bright floodlight on it. Carlson dusts the exposed plate with dyed lycopodium, a vegetable-based powder. After blowing away the excess powder, he affixes the resulting numbers and letters to a sheet of wax paper, melts the wax and makes a permanent copy. "10.—22.—38 ASTORIA." Carlson and Kornei repeat the experiment a few more times to be sure they weren't just imagining it. Then they go out to lunch and celebrate.

Little does Carlson realize how long it will be before anyone else sees reason to celebrate. Kornei leaves him to go on to other work. Carlson keeps experimenting on his own for several more years. He designs a nearly automatic copier and gives his plans to a model maker, but the gadget never seems to work properly. During this time Carlson approaches over 20 major companies for backing and is turned down by all of them, including several future rivals in the copier field—IBM, RCA, Eastman Kodak, and the A.B. Dick Company.

In October 1944, the Battelle Memorial Institute of Columbus, Ohio offers to continue development of electrophotography while guaranteeing Carlson 25% of all profits his invention will eventually make. To raise more money for research, Battelle tries again to interest industry in Carlson's copier and again there are nothing but rejections.

Preoccupied with his invention, Carlson watches his home life disintegrate. His wife sues

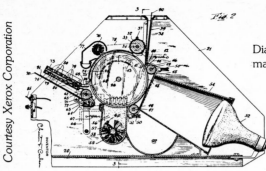

Diagram of Chester Carlson's first automatic copying machine.

for divorce after eleven years of constant disappointment. Alone now, Carlson at 40 is wracked by arthritis attacks. If his luck is going to change, it better be soon.

Finally, in May 1948 Carlson licensed his patents for development and use by the Haloid Company, makers of photographic materials since 1906. The electrophotographic process is publicly unveiled at the annual meeting of the Optical Society of America on October 22, 1948. Haloid calls the system "xerography" or "dry writing." It takes another two years for Haloid to bring out its first commercial dry copier, the Xerox Model D. In the meantime, sensing that payback is near, Chester Carlson invests every cent he can raise to exercise an option which gives him 40% of all fees from the licensing of his patents.

Trust fate to cast one more obstacle in Chester Carlson's path. The year 1950 marks the commercial introduction of another copying method—thermography, which uses a heat-sensitive chemical process. Like xerography, thermography is the invention of a lone dreamer.

In the spring of 1940, while a graduate student in chemistry at the University of Minnesota, Carl Miller grows weary of copying scientific abstracts in longhand. Miller conducts his first experiments with temperature-sensitive coated papers in his campus rooming house. Four years later, while a chemist at 3M, his employer decides to allocate research funds towards what will soon be offered to the public as the Thermo-Fax system. Conveniently packaged in a desk-top unit, this 30-second dry copy process looks like it will bury Xerox and its cumbersome machine.

Chester Carlson's luck suddenly turns for the better. The Xerox machine is miraculously

Patent drawings for Chester Carlson's invention of electrophotography, later known as xerography.

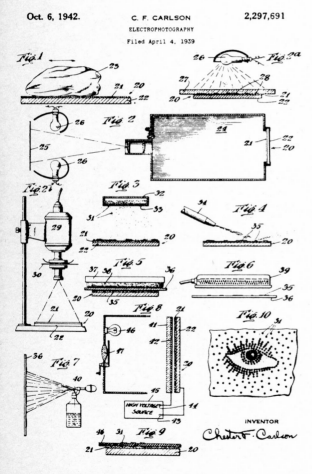

saved by a specialized market in the making of offset printing masters. By the time the next Xerox models are introduced, the process has been simplified to the point where anyone can simply push a button at a desk-sized machine to receive a crisp, clean, plain paper copy. Meanwhile, Thermo-Fax and other coated paper processes encounter resistance in the copy market. Carlson's lifetime investment is saved! He becomes rich. In his later years Carlson settles down in a suburb of Rochester, N.Y. with his second wife, who introduces him to Zen Buddhism. He watches contentedly from the sidelines as his electrophotography machine becomes one of the most widely used inventions of his time and the standard by which all other copy systems are judged.

A QUICK GUIDE
TO COPY PROCESSES

According to modern physics: when reading the words on a page you are actually perceiving bundles of light particles reflected from the paper and captured by your eyes. To copy a visual pattern onto another surface, that surface must be made to reflect light particles in a similar manner. Elemental particles of light—or *photons*—are highly volatile. At a subatomic level, all quick copying processes make use of photons to move electrical particles, or *electrons*, since electrons can be tamed to leave their imprint on many surfaces.

There are essentially two practical means for creating a permanent record of light in the form of an instant copy. In xerography and other electrostatic copy processes photons displace electrons on a surface which has been charged with static electricity. In photochemical processes, chemical reactions are triggered by the interplay of photons and electrons within special compounds.

The major categories of copying systems can be subdivided according to the specific processes they employ. Among electrostatic systems there are indirect or transfer processes, like xerography, which create the copy image on one surface and then apply it to a sheet of paper. Direct electrostatic processes, as their name indicates, form the image right on the copy paper.

For photochemical processes the most common classifications are made according to the types of chemicals they rely on. Light-sensitive silver compounds make standard photographic methods possible. Non-silver photo sensitive chemicals produce the images in special-purpose copies such as architectural drawings.

Though not directly effected by light, heat-sensitive or thermographic chemicals react to the heat generated by photons striking the copy surface.

To the vast majority of copier users, the main distinction between instant copying systems has to do with the format of a finished copy. Dry copies on ordinary paper are generally preferred in office use because they are almost indistinguishable in appearance from typed originals.

The only systems which can presently deliver dry copies on plain paper or other untreated materials are those employing electrostatic transfer processes. Within this category there are processes which aren't strictly dry, like the one used in I.B.M. copiers, since they make use of wet ink toners.

Direct electrostatic systems and all photochemical processes use specially coated papers, which in many cases must be developed with liquid chemicals. For all of their seeming disadvantages, coated paper processes are generally more sensitive to light and give better tonal gradations than plain paper systems.

The distinctions among copy processes are summarized in the table below. Detailed descriptions follow:

Coated Paper

Column headers (rotated): RANGE OF OUTPUT [Continuous run | Multi-copy to (highest setting)] · PAPER FEED [Sheet fed | Roll fed] · ACCESSORIES [Key cartridge: Field retrofit, Factory fit | Collator/sorter | Automatic document feed] · CAPABILITIES [TABLETOP | CONSOLE | ACCEPTS BOUND BOOK PAGES | Duplicating Master Makes Offset | CUTS COPIES TO SIZE OF ORIGINAL | letter size | 11 x 17 to letter size | Computer printout to letter size | Accounting spread to letter size | Legal to letter size] · MAXIMUM SIZE OF COPIES (INCHES) · COPIES/MINUTE [over 30 | 19–29 | 13–18 | 8–12 | Under 8] · FIRST COPY (IN SECONDS) [Over 12 | 9–12 | 5–8 | Under 5] · MANUFACTURER'S RECOMMENDED MONTHLY VOLUME RANGE (no. of copies) [over 35,000 | 35,000–100,001 | 15,000–100,001 | 5,000–15,001 | 1,000–5,001 | Under 1,000] · LIQUID · DRY

Firm Name	Model	Multi-copy to	Max size of copies (in.)
ELECTROSTATIC (DIRECT)			
APECO	M 776	20	11.75x17
APECO	M 686	20	8.5x14
BELL & HOWELL	Emissary	99	11.7x17
BELL & HOWELL	Emissary Dry Copier		11.7x17
BOHN-REX-ROTARY	RR-4000	5	8.5x14
BOHN-REX-ROTARY	RR-4040		8.5x14
DICK, A.B.	695	20	10x14.75
DICK, A.B.	675	20	10x14.5
DICK, A.B.	625	20	8.5x14
ESKOFOT	626	5	8.5x14
ESKOFOT	1626	5	8.5x14
ESKOFOT	1626DT	10	8.5x14
GESTETNER	C-12	20	8.5x14
MINOLTA	1714-II	23	11x14
MINOLTA	1114 TC	20	11x14
MINOLTA	1114 TCA	20	11x17
MINOLTA	1117 TCA	20	11x17
MITA	900 D	20	10x14
MITA	700 D	10	10x14
MITA	500 D	10	8.75 x any
MITA	17 D		17x48
OLIVETTI	Copia 605	20	9.75x14.5
OLIVETTI	Copia 405	15	9.75x14.5
OLIVETTI	Copia 400		9.75x14.5
PITNEY BOWES	358-II		8.5x14
PITNEY BOWES	253	15	8.75 x any
PITNEY BOWES	253-AF	99	8.75 x any
RONEO-VICKERS	DB-30		8.5x14
RONEO-VICKERS	DB-2	20	8.5x14
RONEO-VICKERS	DB-3		8.5x14
ROYAL	1700	15	11.75x17
SAVIN	220	20	10x15
SCM	312-R	23	9x12
SCM	311-R	99	8.5x11
SCM	412	20	8.5x14
SCR	211	20	8.5x14
SAXON	Compact		11.5 x any
SAXON	C-500	15	11.5x17
SAXON	B-12	99	10x14
SHARP	SF501	20	10x14
SHARP	SF305		10x14
SHARP	SF205		10x14
SHARP	SF151		11.7x17
SPEED-O-PRINT	MDC	99	11.7x17
SPEED-O-PRINT	1200	99	10.12x14
SPEED-O-PRINT	1100	11	11.7 x any
SPEED-O-PRINT	900		11.7 x any
3M	VQC II	20	10.12x14
3M	VQC III		8.5x14
3M	732		10.12x14
3M	VQC-SE	20	10x14
TOSHIBA	BD 25	20	11x14
YORKTOWN	2000R	20	11x14
YORKTOWN	1114	99	11 x any
YORKTOWN	XR 500		8.5x14
YORKTOWN	110		
THERMAL			
HEYER	91		11 x any
HEYER	9100		9 x any
STANDARD	Astro-Fax		9.25 x any
SPEED-O-PRINT	2900		8.5x14
3M	Statement Machine		

Plain Paper

Firm Name	Model	Multi-copy to	Max size of copies (in.)
ELECTROSTATIC (INDIRECT)			
APECO	ABC 300	20	10x14
CANON	NP-50	20	11x17
CANON	NP L7	25	11x17
CANON	NP-70	25	11x17
CANON	NP-5000	99	11x17
DENNISON	BC-14	20	11x17
DENNISON	BC-28	20	11x17
DENNISON	BC-22	20	11x17
DENNISON	BC-2000	27	8.5x14
DICK, A.B.	901	27	8.5x14
DICK, A.B.	901S		8.5x14
EASTMAN KODAK	Ektaprint 100	999	8.5x14
EASTMAN KODAK	Ektaprint 100F	999	8.5x14
EASTMAN KODAK	Ektaprint 100AF	999	8.5x14
EASTMAN KODAK	Ektaprint 150	10	8.5x14
IBM	Copier I	20	8.5x14
IBM	Copier II	999	8.5x14
IBM	Series III/10	999	8.5x14
IBM	Series III/20	99	11x17
MINOLTA	Electrographic 201	20	11x17
MINOLTA	EG 101		18x24
MINOLTA	EG 1824		10x14
MITA	MC200D	99	10x14
OCÉ	1600	20	11x17
OCÉ	1620	20	10.1x14.3
OLIVETTI	Copia 1500	99	10.1x14.3
OLIVETTI	Copia 1600	30	8.5x14
PITNEY BOWES	PBC Copier		10x14
ROYAL	RBC IV	20	10x14
ROYAL	RBC III	20	10x14
ROYAL	RBC I	20	11x17
SAVIN	770	20	8.5x14
SAVIN	780	20	8.5x14
SAVIN	760	999	11x17
SCM	6740	99	14.5x17
SAXON	1	99	11x17
SAXON	2	99	8.5x14
SAXON	3	20	10x14
SHARP	SF 730	20	10x14
SHARP	SF 726	20	10x14
SHARP	720	20	8.5x14
3M	VHS-R	99	10.12x14
3M	Secretary II	20	10x14
3M	Secretary III	20	10x14
TOSHIBA	BD-601	20	11x17
TOSHIBA	BD-702A	20	14x22
TOSHIBA	BD-909	99	8.5x14
XEROX	3107	99	8.5x14
XEROX	3400	9,999	8.5x14
XEROX	5400		
XEROX	9400	99	8.5x14
YORKTOWN	Genie		

N/A – Not available. (A) – $1,000 plus excess copy/year. (B) – $125 annual lease charge. (C) – Semiautomatic document feed. (D) – 11x17 inches to 8½ x 12 inches. (E) – Dealer option. (F) – Various plans available. (G) – Optionally available. (H) – $225 and up. (I) – $275 and up. (J) – Fifteen copies per minute in book mode; 30 copies per minute in sheet mode. (K) – Up to 500 copies. (L) – $995 refurbished. (M) – Tabletop unit with optional bracket for attachment to wall. (N) – Up to 1/4 inch thick.

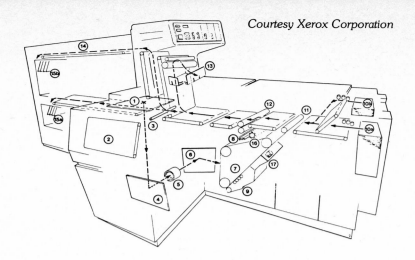

STEP-BY-STEP OPERATION OF THE XEROX 9200 DUPLICATING SYSTEM

Original document is moved to flat platen (1) by automatic document handler (2) and flashed by high intensity flash lamps (3). Image is reflected to object mirror (4) through stationary lens (5) and reflected by image mirror (6) to the selenium—alloy coated belt (7).

The charge corotron (8) places a positive charge of electricity onto the belt. The light reflected through the optical system removes the charge except for the desired image. Developer with negatively charged toner (9) is brushed onto the moving belt and the toner sticks to the charged portions of the belt.

Ordinary, uncoated copy paper is fed from the main paper tray (10a) or the auxiliary paper tray (10b). Image transfer (11) to the paper is achieved as it passes over the belt. The imaged copy is transported to the fuser (12) where heat and pressure fuse the toner image into the paper. The copy is then transported to the receiving tray (13).

When the sorter (14) is used, the copies will automatically feed into the lower bin module (15a) until full, then switch to the upper bin module (15b).

Any toner on the belt not transferred to the paper is removed by a brush (16) and vacuum system and recovered for re-use. More toner is added automatically by a toner dispenser (17).

Electrostatic Transfer Process. Since Xerox still produces the most widely used instant copy system, let's look inside a Xerox machine.

At the heart of the system is a smooth-surfaced metal drum. As the machine begins its copying cycle, in the dark the drum is given an electrical charge of 6,000 or 12,000 volts by an exposed wire called a corona discharger. The surface of the drum is mainly made of selenium, an element with the properties of a photoconductor. In the dark, selenium is an excellent electrical insulator, steadfastly retaining its charge of static electricity, but when light strikes it, the charge dissipates.

In the next step of the copying cycle, a light exposes the surface of the document to be copied and the reflected light is focused by a lens system onto the selenium drum. The electrical charge on the metal disappears, except where a dark area on the original has kept a corresponding area dark on the drum. Thus the original visual pattern is translated into an invisible pattern of electrical charges on the drum's surface.

To develop this electrostatic image, as the drum continues to revolve, it is dusted with a powder composed of particles of dry ink toner tumbled together with beads which give the toner a static charge. The toner clings to the areas of charge on the selenium drum, making a legible copy image.

Elsewhere in the Xerox machine, a sheet of plain paper is given a small electrical charge. The paper is then brought up against the selenium drum. Its charge attracts the toner powder away from the metal surface. This toner image is made into a permanent copy by fusing powder to paper, usually with heat.

There are many variations on this basic black and white process. In high-speed Xerox models, like the 9200, exposure to light is accomplished by a brief flash of four powerful bulbs,

while the rotating drum is replaced by a fast-moving belt. In other brands of copiers, selenium has been displaced by different photoconductors. Toner technologies also vary: IBM, APECO and many Japanese-made copiers use liquid toners, while 3-M has developed toners which are fused by the application of pressure.

The biggest drawback to xerography, or almost any other electrostatic process for that matter, is its difficulty in reproducing solid areas. The reason is simple: an electrostatic charge tends to be stronger at its edges than at its center. This becomes apparent when toner clings to charged areas in developing the copy image. Edges become very dark and large areas drop off into pale ghostly grays.

Since lines, letters, and numbers are essentially all edges, xerography has no problem with making most office copies. It's when called upon to reproduce photos and artwork that electrostatic systems have difficulty. One way around this is the use of a half-tone screen, a printer's tool which turns image areas into patterns of black dots.

Among the advantages of electrostatic transfer copies are their high contrast and wide exposure latitude (allowing copies to forgive smudges and corrections on originals), permanence (the carbon black in many toners will outlast the paper it is fused to) and those qualities inventor Chester Carlson envisioned for his ideal copier—speed, economy, and the attractiveness of plain paper copies.

Electrostatic Direct Processes. Eliminating the need for an intermediate image-forming step, electrostatic direct processes turn the copy paper itself into a photoconductive surface. To accomplish this, the paper is precoated with a layer of zinc oxide, an inexpensive, white pigment which is widely used in paints and pharmaceuticals. Zinc oxide's light sensitivity is largely confined to the invisible ultraviolet range, so special sensitizers are added to make the

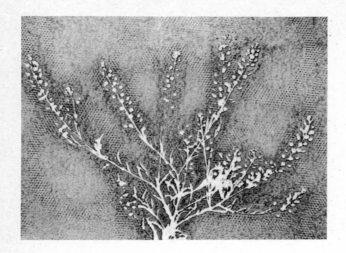

Linton Godown

"Plant Photogram"

1970, APECO Zinc Coated Paper, Electrographic Monoprint, 8½" × 11".

Linton Godown describes the technical features of the actual print making process here as "Electrographic". The colored image is the result of attracting minute particles of pigment to electrostatic charges on the surface of specially prepared and treated Zinc oxide paper, much as iron powder would be attracted to a common magnet. The invisible charge can be modified in various ways to create images which in turn are rendered visible by application of pigments, which themselves have different electrical characteristics.

paper respond to visible light.

In a direct electrostatic machine the initial copying steps are similar to those in the Xerox copier: a photoconductive surface is electrically charged in darkness and then exposed to light reflected from the image to be copied. Because the electrostatic pattern is formed on the paper itself, however, toner is applied directly to the paper to develop and permanently imprint the copy image.

While the idea for direct electrostatic processes was originally explored at the Battelle Institute under contract to Xerox, commercial introduction of direct copies did not occur until RCA unveiled its Electrofax system in 1951. Among RCA's innovative developments was an improved method for applying dry toner, using a mixture of powdered ink and iron fillings brushed across the charged paper by means of a magnet. (A similar method is employed when police dust the scene of a crime for fingerprints). In developing electrostatic copies, this magnetic brush assures more uniform distribution of toner across large image areas.

Though Xerox was able to assert its patent rights over RCA's system, other manufacturers have continued to perfect zinc-oxide copying techniques. Direct electrostatic copiers from 3-M, APECO and Japanese firms are making increased use of toners in liquid suspension instead of dry toners.

Liquid toner partisans point to crisper image resolution, more even tone reproduction and finer detail on copies. Also advantageous are lower internal temperatures for their machines, since liquid toners don't have to be heated as much as powders to fuse to the paper's surface.

Companies using dry developers claim better contrast and deeper tones as well as the convenience of not having to store highly flammable liquids.

In the past, direct electrostatic copiers have met with customer resistance. Besides the odd tactile feeling of coated copy paper, the particular disadvantage of the zinc oxide surface is its tendency to form cracks when folded and to mar easily when any metal comes in contact with it.

Still, a big plus for direct electrostatic copiers is their reliability, thanks to the relative simplicity of their innards. Such machines have increasingly cornered the market on coin-operated copiers in libraries, post offices, and stationery stores.

Photochemical Silver Processes. The very earliest systems for copying documents were based on the silver compounds used in photography. In 1839, about the same time Paris theatrical promoter Jacques Daguerre was putting the final touches on the first practical photo camera, a German student named Albrecht Breyer was testing silver photochemical coated papers for copying a printed page.

During the 1900's, photocopying equipment—slow, cumbersome, messy, and expensive, yet indispensable for many tasks—began to make its appearance in large offices and printing shops. Over the years, variations on basic photographic chemistry have yielded more manageable copy systems which are competitive with electrostatic processes.

At its simplest, the photocopying process makes use of silver compounds known as silver halides, which change chemical composition when struck by light. To render these invisible changes into a readable image, the silver compounds are treated with developing chemicals which turn the light-struck grains into black metallic silver. In copying an image, light areas are transformed into dark areas of developed silver while dark areas on the original leave corresponding areas on the copy surface unexposed and therefore, white. As a result, the original image's tonal values are reversed on the photocopy and a negative image is obtained.

Restoring tones to their original relationship in a positive image requires another exposure of silver compounds to light and/or chemicals. Intermediate chemical steps are also usually necessary, including a stop bath to halt the action of the developer and a fixer bath to make the image permanent. In addition, a lengthy bath in running water is often required to wash away unstable chemicals.

Photostats were first produced in France in 1906. Using a large precision camera to photograph a document directly onto silver halide coated paper, a photostat develops into a white on black image, from which a direct positive can be made in an additional procedure. Because of long developing, fixing, and washing times (often totalling 10 to 30 minutes), the standard photostat can hardly be considered an instant copy. Special liquid stabilization compounds can significantly speed up chemical processing of photostats, but they yield copies which are subject to fading and discoloration with time.

The diffusion transfer reversal (DTR) process, a major advance in silver photocopying techniques, was introduced in 1950, the same year xerographic and thermographic office copiers made their debut. DTR allows the making of a negative and a positive image in one processing step, which takes less than a minute. For several years, more manufacturers (among them APECO, A.B. Dick, and G.A.F.) produced DTR copiers than any other type of instant copy machine. Eventually, having to use two differently coated sheets of paper to make a single copy proved too inconvenient for most users and the DTR process faded in importance.

In 1953, Eastman Kodak announced its Verifax copier, the first to use the gelatin dye transfer process. This copy method uses a silver halide coated paper master, or matrix, to imprint up to 10 copies on plain, uncoated paper. Verifax matrix paper is translucent, with a

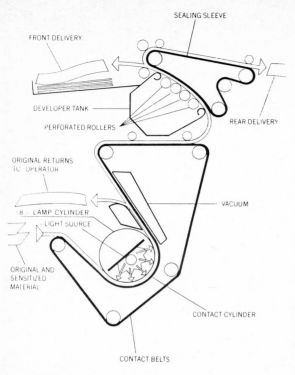

SEALING SLEEVE

FRONT DELIVERY

DEVELOPER TANK

PERFORATED ROLLERS

REAR DELIVERY

ORIGINAL RETURNS
TO OPERATOR

VACUUM

8 LAMP CYLINDER

LIGHT SOURCE

ORIGINAL AND
SENSITIZED
MATERIAL

CONTACT CYLINDER

CONTACT BELTS

(Courtesy Bruning, Div. of Addressograph Multigraph)

recognizable gelatine and silver coating on the emulsion side. After contact exposure with an original document in bright light, the matrix paper is activated by a chemical bath. Light-struck areas harden, while in unexposed areas the gelatin and blackened silver remain soft enough to transfer a crisp image to untreated paper.

Drawbacks to silver halide systems are numerous: the necessity for wet chemical developers, the perishable nature of unexposed photocopy paper, and chemicals as well as the increasing scarcity and expense of silver itself. On the other hand, photochemical silver processes offer the advantages of unparalleled versatility, wide-ranging contrast and tonal control, ultra-sharp resolution, and archival permanence.

Photochemical Non-Silver Processes. Silver compounds are not the only chemicals useful for photocopying. The first practical duplicating method was actually a non-silver chemical process, invented in 1842 by English scientist John Herschel. His system, still in use today, employs iron compounds which are light-sensitive. A special translucent original is necessary for obtaining copies and only ultraviolet light can produce the desired photochemical reaction. The result of this process is a white line negative image on a blue background, hence its name, the blueprint process. Blueprints are used for engineering and architectural drawings—often on coated cloth or plastic rather than on paper.

The diazo, or whiteprint, process is similar to the blueprint method in requiring a translucent original and exposure to ultraviolet light. It, too, is used in the duplication of technical drawings, but unlike blueprint, the diazo system yields a positive black on white copy, which makes it suitable for office use. In fact, diazo remains the cheapest copying process around. Originally developed during the 1920's in Germany by a former Benedictine monk, diazo

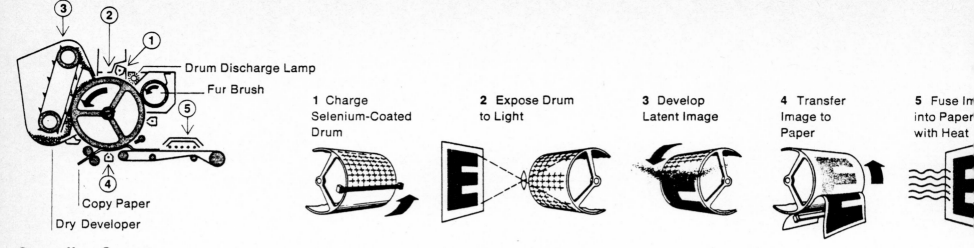

Drum Discharge Lamp

Fur Brush

Copy Paper

Dry Developer

Courtesy Xerox Corporation

1 Charge
Selenium-Coated
Drum

2 Expose Drum
to Light

3 Develop
Latent Image

4 Transfer
Image to
Paper

5 Fuse Im
into Paper
with Heat

makes use of nitrogen compounds which are altered by exposure to light. With development in an ammonia solution, the diazo copy reproduces only those areas which were dark in the original.

Both whiteprint and blueprint processes share the disadvantage of needing specially prepared originals and a non-standard light source. Whiteprint has the added problem of using highly toxic ammonia solutions, while a blueprint is slow to make and produces a copy which many people find hard to decipher.

The advantages of these non-silver processes include low cost, permanence, and unusual texture and monochromatic color effects.

Thermographic Processes. In a thermographic, or "heat writing" process, heat lamps are used to imprint a temperature-sensitive coating on the copy paper. The original 3M Thermo-Fax paper simply consisted of a white wax coating on a dark background; when the wax melted, the dark backing showed through in the form of the reproduced image. Problems with sharpness and the awkward feel of the paper caused Thermo-Fax to switch to a temperature-reacting chemical coating for its paper.

To produce a Thermo-Fax copy, the coated paper is placed face up, with the document to be copied face up behind it. Heat beamed at these papers passes through the blank copy sheet, but is absorbed by the dark image areas on the document. This heat is sufficient to trigger dye-forming chemical reactions on the copy paper and a duplicate image is obtained.

Though popular for many years after their introduction, thermographic processes have largely succumbed to their built-in drawbacks: originals must be unbound, colored inks will not reproduce, and copies remain sensitive to heat. Thermo-Fax materials are unsuitable for duplicating other copies because they tend to melt together.

The great advantage of thermography remains the simplicity of the process. Since chemical reactions are heat-induced, no developing step is necessary. As a result, thermographic copiers are uncomplicated in structure and require little maintenance.

Color Processes. Copiers capable of producing full-color reproductions are a relatively recent development, although the systems they use are merely variations of the processes described above. To obtain a range of color combinations three or even four toners are needed instead of the one used in black and white copiers. The added steps of exposure and development add to the complexity of color copying equipment.

For several firms the manufacture of color copiers has proven a losing proposition. Both Apeco and Hitachi developed liquid toner color systems which were abandoned because of financial difficulties. The hard-luck story of 3M's Color-In-Color system has already been recounted; the few 3M color copiers still in public use are much sought after by copy artists.

For its high-quality reproductions, the 3M Color-In-Color system uses both electrostatic and thermographic copy techniques. A color original is successively exposed through red, green, and blue filters in a manner similar to the color separation process used by printers. Each exposure is electrostatically copied as a black tonal image directly onto a sheet of zinc-oxide coated foil. This intermediate copy is then used for heat absorption in thermographically transferring dry toner layers of three basic colors (yellow, magenta, and cyan) to plain copy paper by vaporization.

The combined basic colors blend easily to form a wide range of distinct colors. Among the controls provided by the Color-In-Color machine are density, contrast, color saturation, and a color rendition selector which permits the creation of twenty-seven different color combinations from a single original. While they were manufactured, Color-In-Color copiers were offered in

two distinct configurations: System I for reproducing opaque originals and System II for enlarging and printing color slides. Though relatively expensive to operate, the Color-In-Color machine is the only available copier designed specifically for Full-color pictorial reproduction.

The Xerox 6500 color copier was conceived around the reproduction of a limited number of saturated colors for use in charts and graphs. Thus it is designed to accurately render just seven colors: cyan, magenta, yellow, and their simplest combinations, red, green, blue, and black.

Xerox explains the workings of the 6500 this way: "The original is scanned three times. Three images—one each through a red, green, and blue filter—are projected on the photo-receptor drum. Each image is developed by the cyan, magenta, or yellow toners as the drum rotates, and electrostatically transferred onto ordinary unsensitized paper in perfect registration. Magnetic brush development of the images, which deposits the toner on the drum in layers, provides for extremely high-quality coverage on halftone or solid areas."

The powdered toners used in the Xerox color copiers are fused by heat, but the resulting mixing of hues leaves much to be desired. Still, the 6500 is the only widely available color copier, and the convenience of obtaining a full-color permanent print in just 33 seconds is hard to beat. A recent improvement in the 6500 makes use of a laser system to scan a color image off a television screen, allowing what Xerox terms "hardcopy reproduction directly from computer generated color graphics imaging systems." Laser scanning could lead to an entirely new color copying system from Xerox.

Meanwhile, other companies are not resting on their toners; their efforts with color copying processes should eventually result in the same kind of competition which made black and white copying so inexpensive and readily available.

COPYART

Peter Thompson

From Triptych: "On the Idea of the Opening and the Daubbing of the Sea Surfaces with Middling Beasts Off Brindisi"

1976, Ink, Acrylics, and Xerox Prints on Multiple-toned Silver Print, 9½″ × 12½″.

"Let people know that 'ART' is about themselves, and often times it's a great revelation. It can change lives."

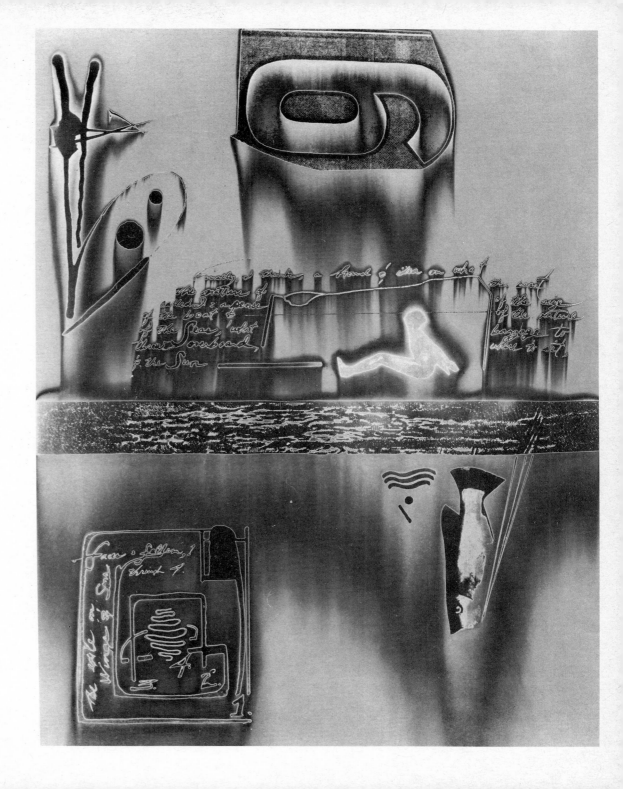

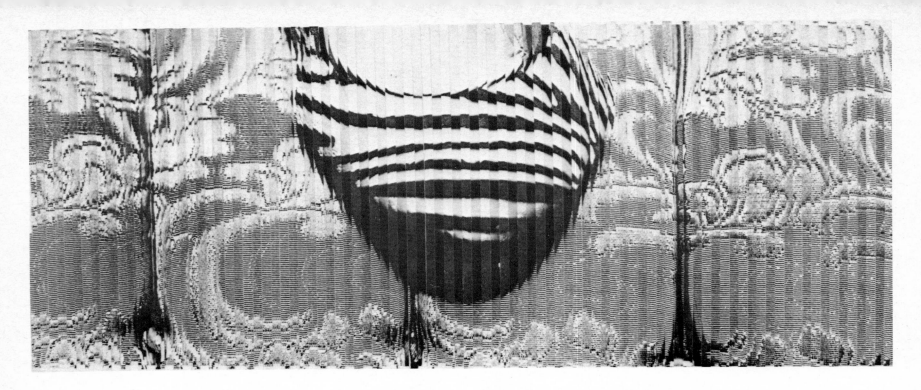

Rob Noah Wynne

Untitled

1975, Black and White Photograph and Xerox 6500 Color,
8″ × 19″.

Both the black and white photograph and the color
Xerox copy are cut into ¼″ strips. Then they are
put back together again, interpolating first one strip
of photo, then one strip of Xerox, over and over
again until there are two images of the same image
in one.

"I have been using both copy machines and
blueprints for many years because I especially like
the color that can be had when one processes a
black and white photo through the "full" color of
the Xerox 6500. It is like yet another camera."

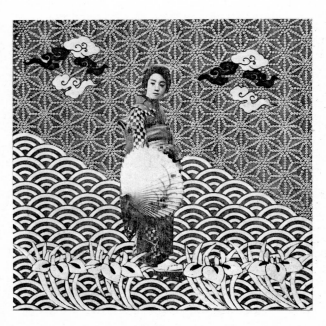

Sidney Wasserback

From "Japanese Dreams"

1976, Collage and Montage
on Black and White Xerox,
5″ × 5″.

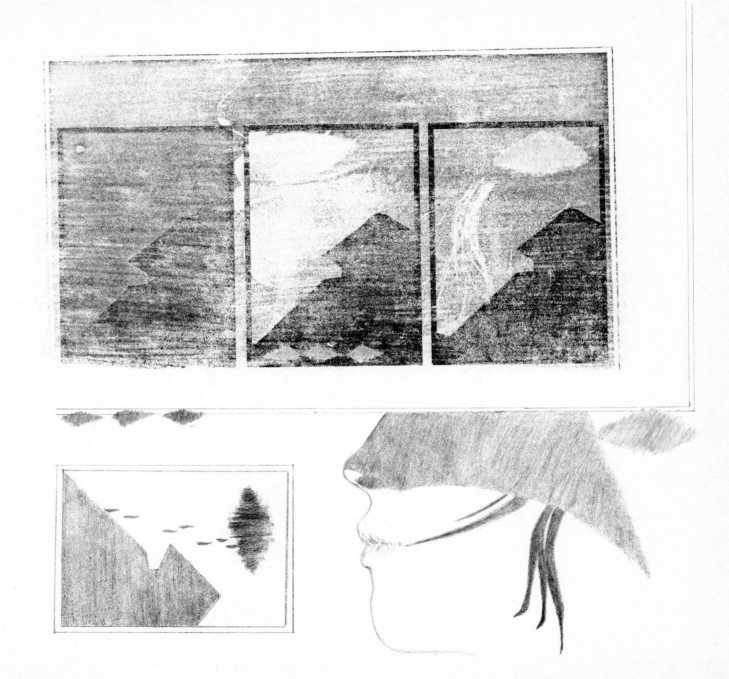

Leslie Knowlton

Untitled

1978, Haloid Xerox
Transferred to Paper,
13″ × 13½″.

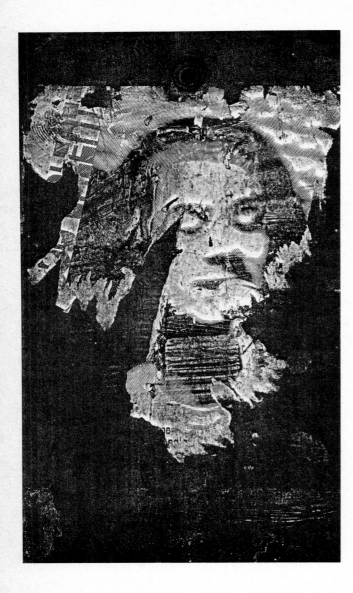

Charlton Burch

"Found Object" (left)

1976, New York City Street Lamp Plate on IBM
Copier II, 8½″ × 14″.

"I believe that the copying machine is perhaps the
greatest reproduction and image-making tool of
the 20th century, literally returning the power to
transmit back to the people. As such it is a kind of
lowest common denominator in the visual
communications process.

Steven Mendelson

"Modesty" (right)

1977, Ozalid Process, 36″ × 84″.

"My "actinographs" are breaking motion down into
its specifics. They are a sensual cross between
daVinci anatomical drawings and stop action
instant replay. They have an impressionistic life of
their own, sometimes mysterious, sometimes
bending time and space.."

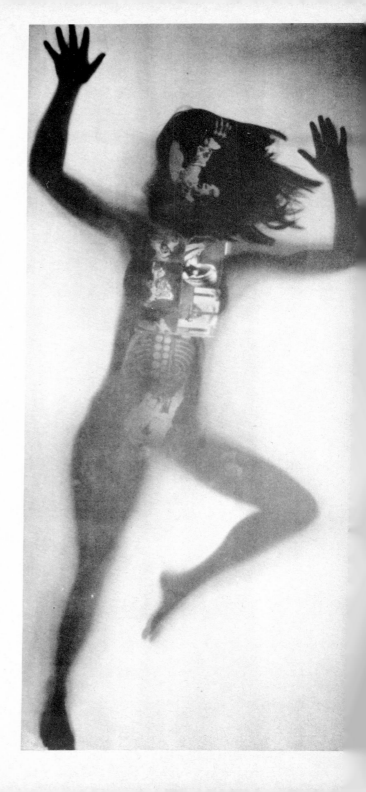

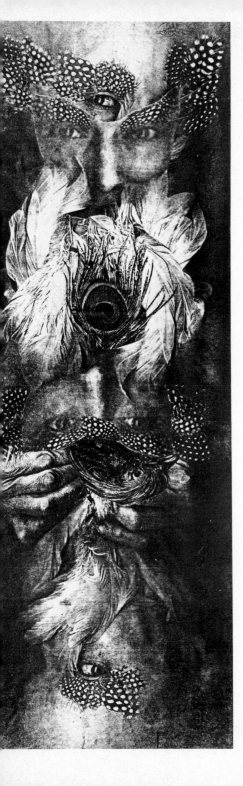

Penny Slinger

"Fan Dance"

1977, Collage and Black and White Xerox, 8½″ × 40″.

Four images are joined together to form a scroll in this surreal feathered fantasy.

Susan Weil

"Soft, Silk Mao"

1975, Silk Banner on Xerox 6500 Color Copier, 8½″ × 14″.

This is one of a series where different fabrics and banners are crumpled, folded or torn and laid directly on the 6500 Color copier.

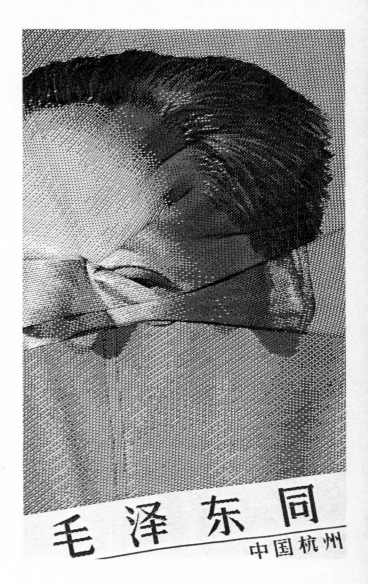

Daniel Barber

"Measuring Stick: Arm Length"

1977, Set of Cards made on Xerox 9200, 6 pieces, Total Size
4″ × 34½″.

"I am full of ideas and nonsense and my art helps
to explore and exploit that part of my existence.
The actual printing makes the work complete and
thereby available for enjoyment and critique.
Otherwise, there would be no communication, no
discourse, and no art."

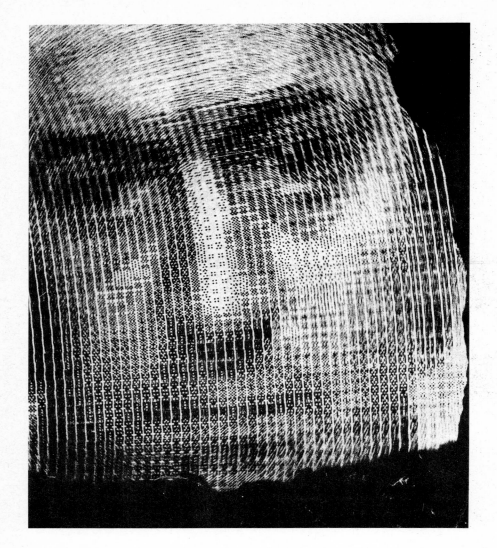

Aldo Tambellini

"Self Portrait" (left)

1977, Computerized Photograph Reprocessed with 3M VQC,
8½″ × 11″.

"Directness—immediacy—involvement with the
process of media—the availability of technology in
mass culture, imaging—the instant act of
information—networks of communication.

You are the image of an image of an image, each
step removing you, making you an archaeological
fossil during your lifetime. Cloning is a form of
Copy Art."

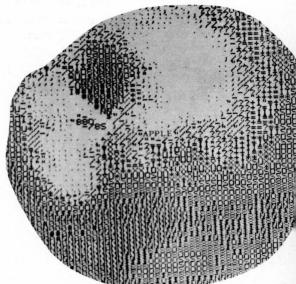

Craig Goldwyn

"Apple Announcement" (right)

1975, Computer Print-out on Zinc Oxide Paper, Video,
8½″ × 11″.

A 35mm slide was printed in black on zinc oxide
under a convention darkroom enlarger and hand
developed in a tray. This image was then
video-scanned and printed out on a computer in
manner which is very similar to the technique
developed for the novelty portraits so popular t

Jeffrey Schrier

"Female Man"

1977, Xerox 6500 Color Copier, Collage Book Jacket, Bantam
5″ × 7½″. Reprint Courtesy: Master Eagle Gallery.

"Collage is a medium through which it is possible
to reproduce a segment of the stream of internal
images that rapidly pass through the mind as a
result of dream and fantasy. It also can be reflective
of the external images of our media culture.
As an artist creating and living from my work in the
70's I am primarily concerned with the man made
outer visual experience, "the media," and man
created inner visual experience, "the dream." My
art is a juncture where these two realms of
experience meet.
"My collages demonstrate how the most
contemporary image making devices, such as copy
machines and instant film cameras can enhance
creativity for the artist, by providing new areas of
technical experimentation and granting him more
instantaneous results."

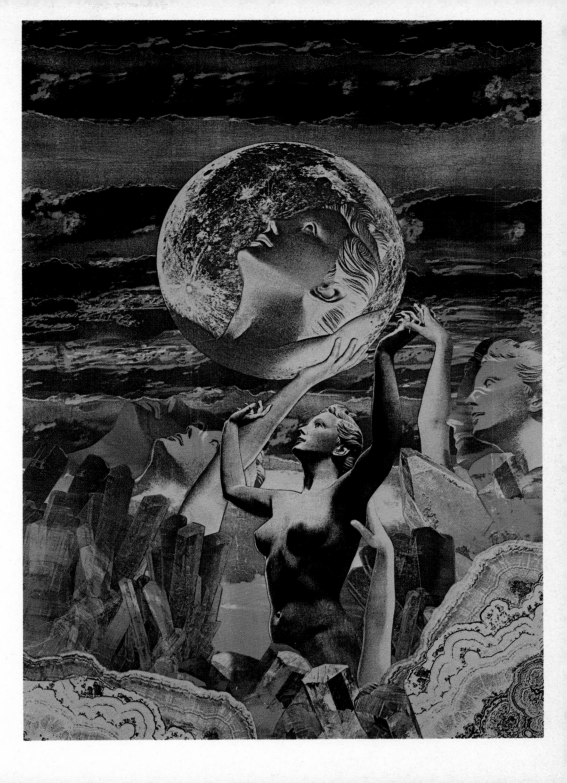

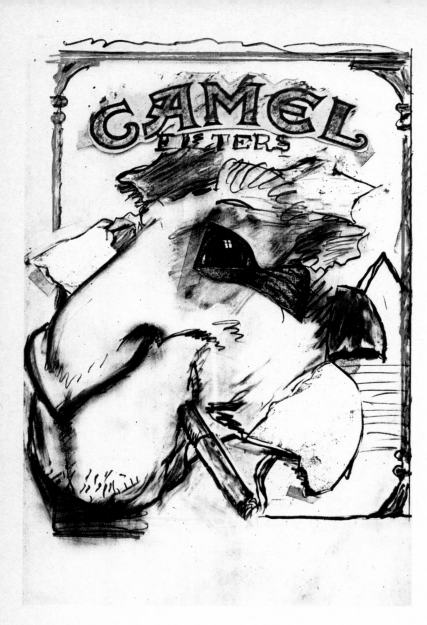

Larry Rivers

"French Camels"

1977, Xerox 6500 Color Copier, 8½" × 14".

This piece utilizes collage and montage techniques in combination with a color Xerox copier.

"I love the instantaneous results you get with the color copy machine. In traditional printmaking it would take days for them to return your proofs, only to have to send them back for color corrections."

Patrick Firpo

"Objects" (right)

1978, Xerox 6500 Color Copier, 8½″ × 11″.

"This piece was so simple yet so effective that everyone who saw it urged me to include it here. I simply laid a handful of objects on the document glass and pushed the button. The quality is outstanding. Not photographic and yet . . .

As a camera, the 6500 has many possibilities still to be explored."

Barbara Astman

"Self Portrait in Pink" (left)

1978, Postcard, Offset Print of Xerox Color Print, 5″ × 7″.

This postcard is a direct print from color separations made on a Xerox 6500 Color Copier.

"My main interest is in image-making. A term I like to use is "Camera Art." I'm more concerned with content, and I use or abuse different media to reach a ground for the idea I am dealing with. I see the machine merely as a tool, (a very amazing tool!) the way a printer may view a litho stone or a photographer his camera. The machine does not make art—Artists make art and a part of that art-making process may involve copy machines. I love the immediacy of the process and the way it distorts color."

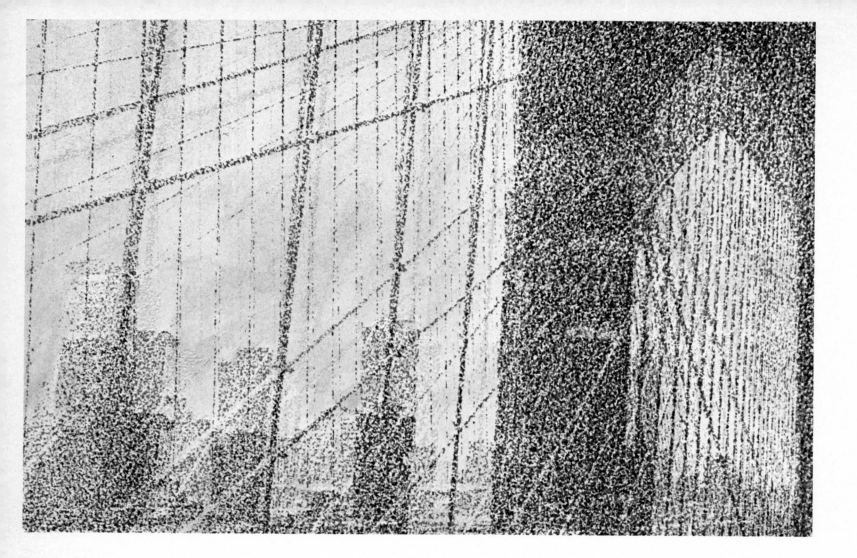

Geoffrey Gove

"Brooklyn Bridge"

1975, Xerox 6500 Color Copier, 5½″ × 8½″.

Color Copy print made from a Black and White photograph, with a superimposed line screen to break up the image.

"I have recently been using copy machines as an intermediate process in my work, as a means of converting black and white images into color. I have found that certain prints are enhanced with a graphic dimension that somehow gained from the increased contrast and simplified color."

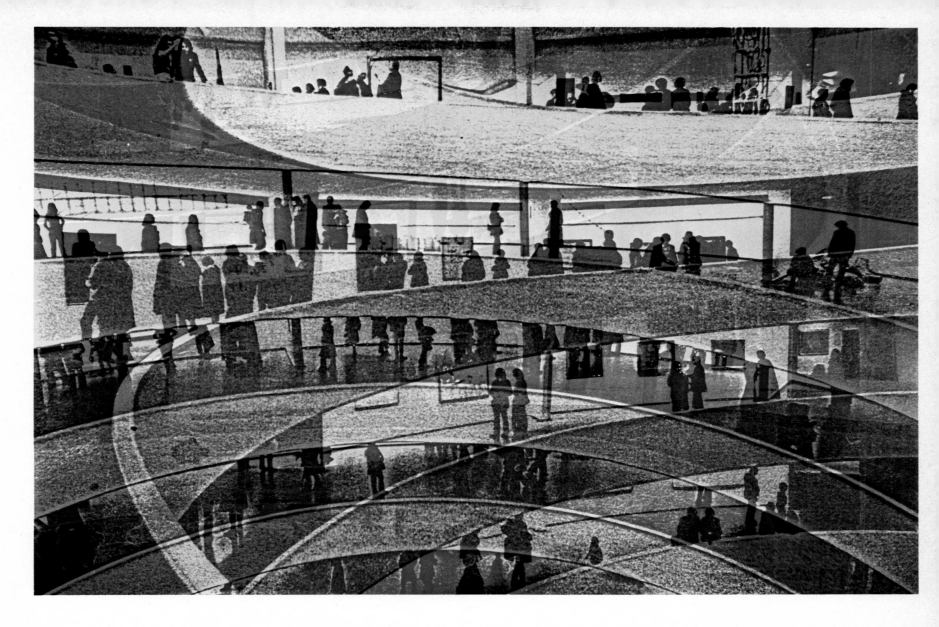

Jack Kaminsky

"Guggenheim"

1977, Xerox 6500 Color Copier, 6″ × 9″.

This print was made by manipulating and superimposing three of his own black and white photographs on the color Xerox machine.

"Color Xerox allows me to achieve multiple images without all the filters, calculations and problems of doing it with my camera or enlarger. I can add controlled color to my black and white photographs and the quickness of the Xerox process allows me to immediately analyze and adjust the results if necessary."

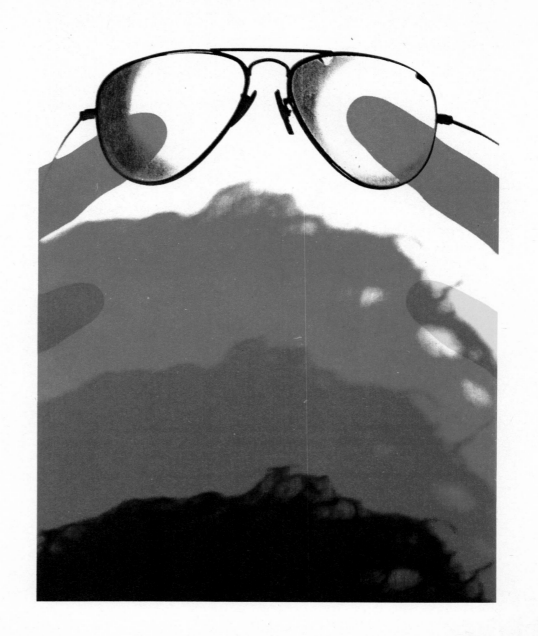

Patrick Firpo

"Hand Dance V" (left)

1977, Xerox 6500 Color Copier, 8½″ × 11″.

"'Hand Dance' was a series of 21 pieces done in
one session. It was created by using the slide
projector as a back light onto the plastic lens
assembly and using my hair as a mask during the
three scans of the color light bar. The glasses were
laid directly onto the plastic lens assembly."

"Lumins" (right)

1977, Xerox 6500 Color Copier, 8½″ × 11″.

"Lumins was created by using hand-held mirrors
reflected off of the slide projector and directly onto
the plastic lens assembly. By moving the mirrors
between each scan, you can achieve dramatic
slashes of pure color which I choose to call "light
paintings."

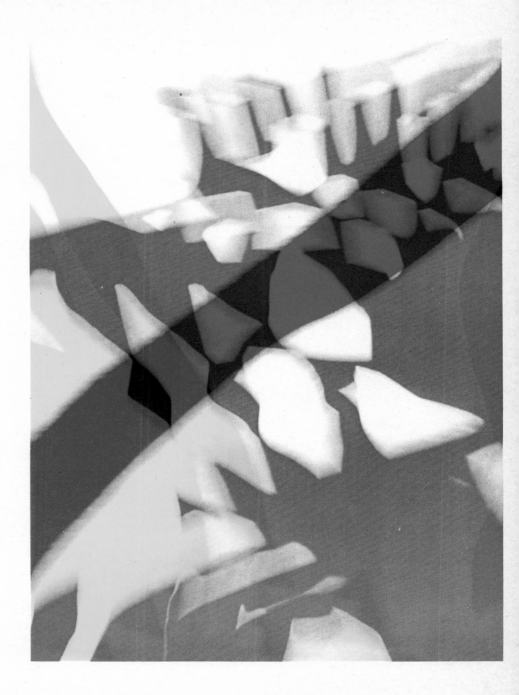

Kasoundra

"The Book of Jeffery Lew: Read Red"

1978, Xerox 6500 Color Copier, 8½″ × 11″.

Kasoundra utilizes cut-out images, loosely placing them in her collage backgrounds so that she can make a copy print and then use the same image or background to make a completely different collage print without damaging any original material in the process.

"There are no new ideas—we just yearn to be inspired and to learn to think."

Dina Dar

"Metamorphosis"

1977, Xerox 6500 Color Copier, 8½″ × 11″.

Objects, such as fans, puppets, flowers and fabrics
are placed on the glass of the Xerox copier and by
moving them in closer or out further to create a
sense of depth and then modifying the colors, I
produce many effects using the same iconography
arranged and photographed in different set pieces.

"I try to capture in my work the paradoxical nature
of life in which undisturbed beauty sometimes
surrounds the violence and intrigue of human
events."

Kris Krohn

"Lighting Strikes"

1977, Xerox 6500 Color Copier, 15" × 16".

These two superimposed Color Xerox Prints are part of a series mounted on Museum Board with cut-outs to show the changing moods of a single interior.

"My technique employs the use of two basic elements; a photo image, either a print or a 35mm slide and an abstract surface. These surfaces are made by various types of paint and liquid on clear acetate. When the "wet surface" is placed between the glass document of the copier and the photograph, sufficient distortion takes place to give the "photo-realism" a mood."

Jeffrey Schrier

"Shunga Fantasy"

1978, Collage based on Erotic Art of Japan, Xerox 6500 Color Copier, 16″ × 21¾″.

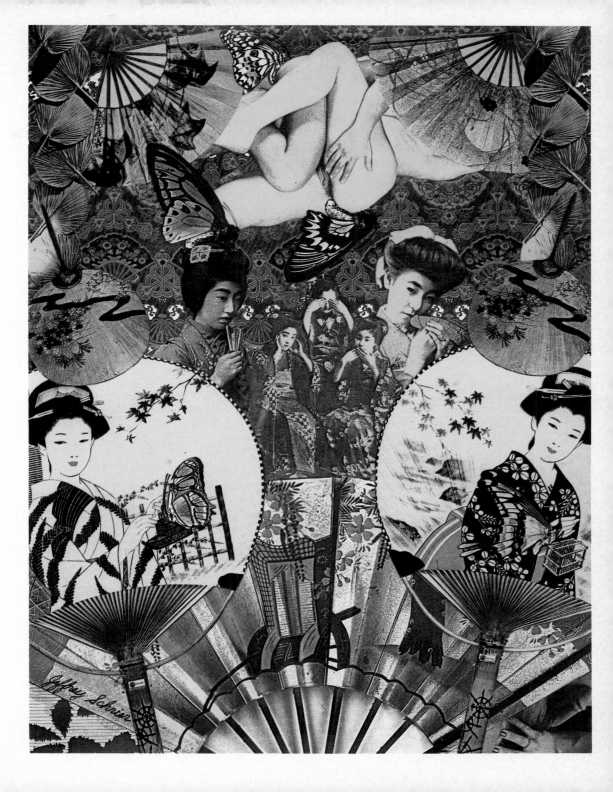

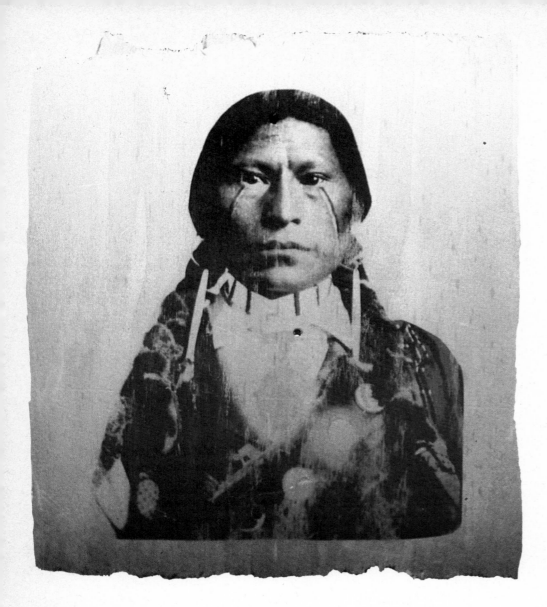

Tyler James Hoare

"Head" *(left)*

1973, 3M Color-in-Color on Wood, 10″ × 12″.

This sculpture piece was made with a 3M heat transfer on to wood.

"I make my collage from magazine cut-outs, photos, newspapers or just about any photo media. I have found, in the case of the 3M Color-in-Color machine that it likes hot colors; red, yellow and orange. It also likes photos of chrome as on a car or truck. I say the machine likes this or that as if it had a mind of its own; it does."

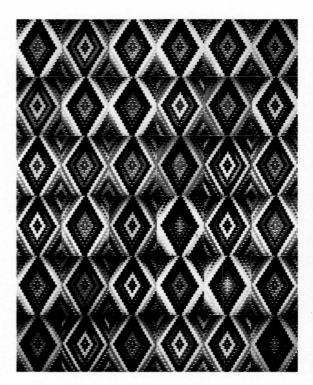

Patrick Firpo

"Look Both Ways Before You Cross"

1978, Xerox 6500 Color Copier, 8½″ × 14″.

"This piece was created by placing my face directly on the document glass of the machine. As the machine completed its second scan, I turned my head the opposite direction and hoped that the alignment of the eyes would be correct. It was! Which goes to show that art is about 50% vision and 50% creative accidents!"

William Gray Harris

"Video Weaving, Series #1a" (left)

1975, 3M Color-in-Color Systems II, (print size: 8½″ × 11″), 36 prints, 4 modules. Original slide taken of a CRT showing live, direct video-synthesis by Stephen Beck.

The original 35mm slide was enlarged and reproduced on bond paper in various color renditions and in different mixtures of the three-color balance, magenta, cyan and yellow. This color balance was achieved by adjusting the three color dials on the side of the machine; it amounted to the ability to synthesize colors. The combination of synthesis and rendition offered a virtually infinite spectrum of color variation.

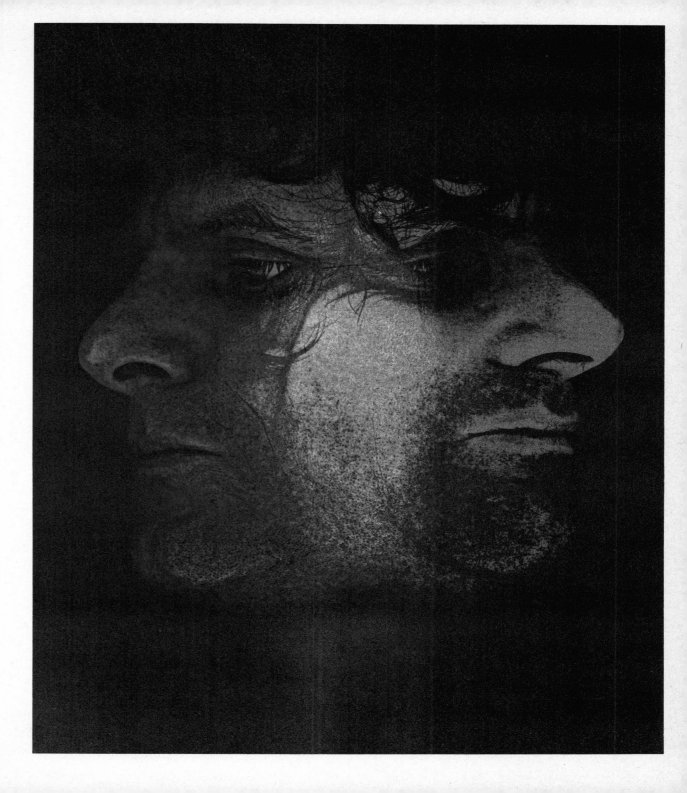

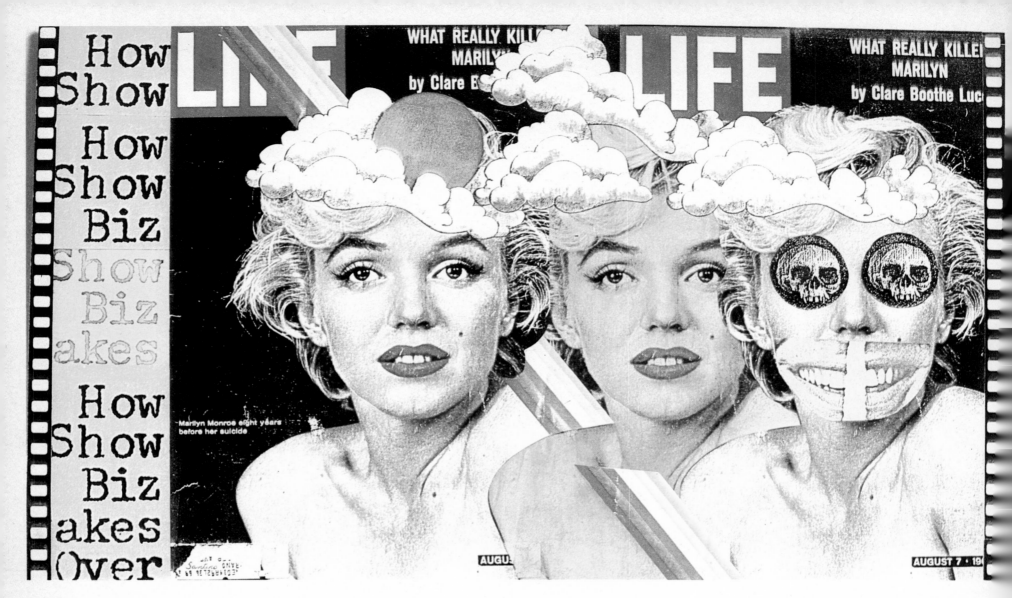

Richard Santino

"How Show Biz Akes Over"

1974, Collage and Xerox 6500 Color Copier, 14″ × 26″.

Richard Santino

"The Greta Garbo Home for Wayward Boys and Girls".

1977, Xerox 6500 Color Copier, 13½" × 15¼".

"Collage exercises the mind's prowess at fragmentation even before that prowess settles into composition. The truly creative collage artist sees but a fraction, and the eye hastens to fill in the complete image. Most other art forms begin with the artist's conjuring of an entire image before he starts the actual work. The whole is apparent, from the outset, or so it seems. Collage formation relies on getting these mental fragments into tangible shape. For example, that day, old blue corduroy may symbolize moonglow. The impact is there. Painters use paint, sculptors clay, to transfer the mind's creative power into something concrete. But for me the image must be pieced together like a puzzle. It has flexible edges, but it's a puzzle nonetheless. The sooner these images, received during the conceptual stage, are put in hand for pieces with which to work, the less is lost, through variation, on the original visual impulse. Nowadays, this precise moment is more apt to be captured intact—thanks to copying machines. Old blue corduroy becomes easily accessible; moonglow becomes fact."

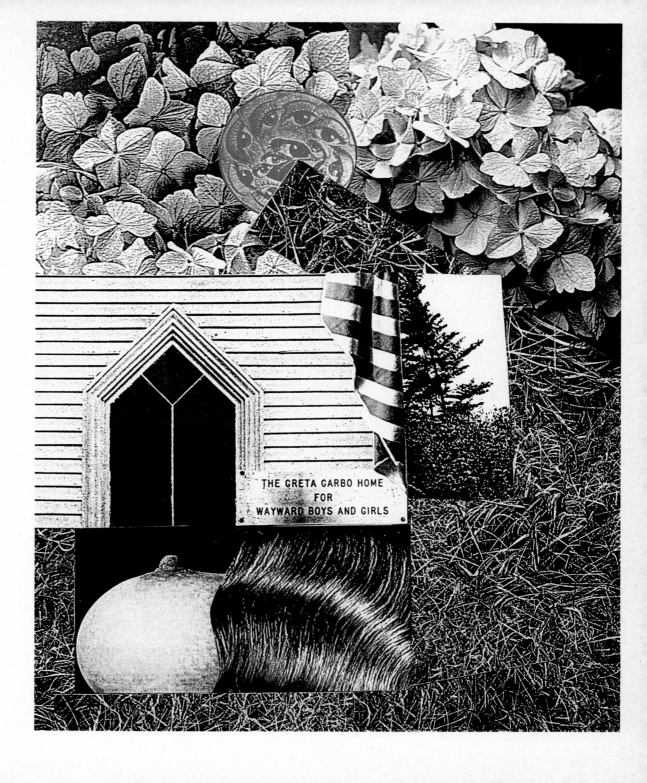

THE GRETA GARBO HOME
FOR
WAYWARD BOYS AND GIRLS

Patricia S. Abbott

"Star Flower" (left)

1978, Polarization and Xerox 6500 Color Copier, 8½″ × 11″.

This print is made by polarizing and then color xeroxing transparent designs. The manipulation of the polarizing material causes shifts in design as well as in color.

"The copy machine may have created a new breed of gambler—the color copier junkie, unable to stop "playing it" until it spits out that perfect print."

Johanna Vanderbeek

"Leaves" (right)

1976, Xerox 6500 Color Copier, 8½″ × 14″.

Johanna has experimented with placing real objects directly on the color copier, as shown here in her leaves composition.

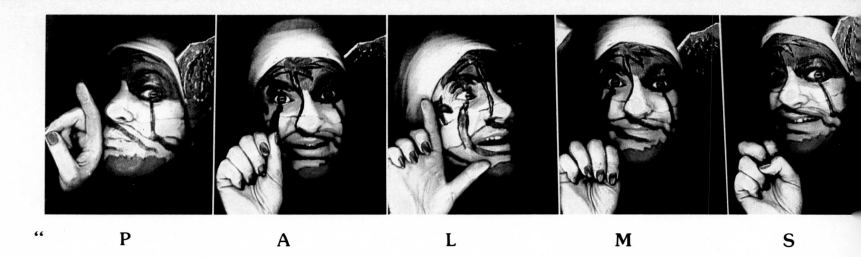

Jane Zingale " **P** **A** **L** **M** **S**

"Palms To You"

1977, Xerox 6500 Color Copier, 10 Prints: Total size 22" × 48". Jane paints her face and then "performs" on the copy machine. Her lips sound out each letter, while her right hand also spel

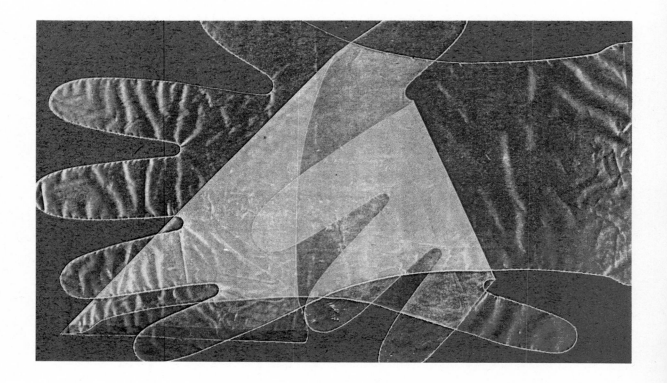

Sari Dienes

"Gloves"

1974, Xerox 6500 Color Copier, 8½" × 14".

By her artistic placement of the rubber gloves on the copier, Sari Dienes has created a subtle color shift with the overlapping of this translucent material.

"I find it necessary to take a stand that will permit Nature to be revealed, that will accept what is real. If it is a mystery, then a mystery not to be judged as beautiful or not beautiful, nor to be liked or not liked."

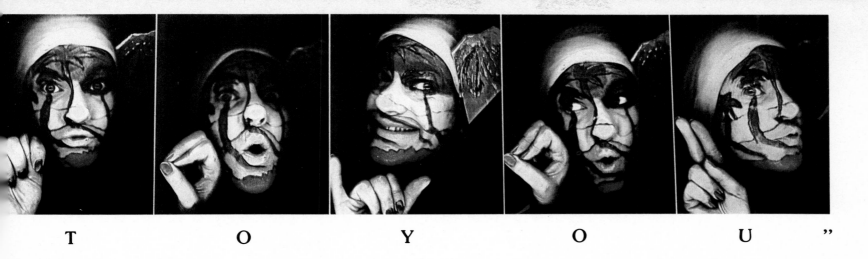

T　　　　O　　　　Y　　　　O　　　　U　　　　"

letter with the sign language used by deaf-mutes.　　　"At times . . . I have been called a closet actress."

Patrick Firpo

"Hand Fresco"

1978, Xerox 6500 Color Copier, Heat Transfer on Rag Paper, 8½" × 11".

"This piece is basically an accident that lived. It was first created on ordinary Xerox paper. A print was made of this copy onto heat transfer paper. This was then ironed onto very fine rag paper. The secret here is that the original copy was removed before the hands went through the fuser; thus the fresco texture."

Allan J. Lerner

"Laughing Gas"

1978, Xerox 6500 Color Copier, Collage 12″ × 12″.

"Laughing Gas" is a view through the interior window of altered consciousness, where sense of self is dislocated in Time and Space, where shape and colors convey meanings apart from everyday perceptions."

William Gray Harris

"Path of Enlightenment"

1973, 3M Color-in-Color System I, 8½" × 11".

"This print is from a series of fifty original collages, the "Space/Time Series," in which images of contemporary Western outer-space technology and those of ancient Eastern inner-space mysticism are commingled. The message: the further out we get, the deeper in we get. All originals were printed in at least six color renditions, in which one color was exchanged for another by employing the nine button color composer. Twenty-seven color variations could be achieved by the use of this filtering method."

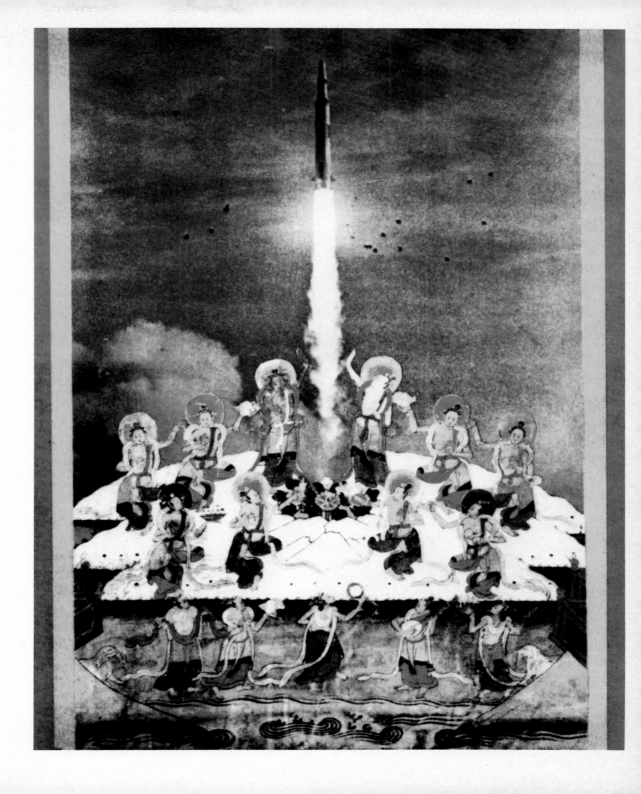

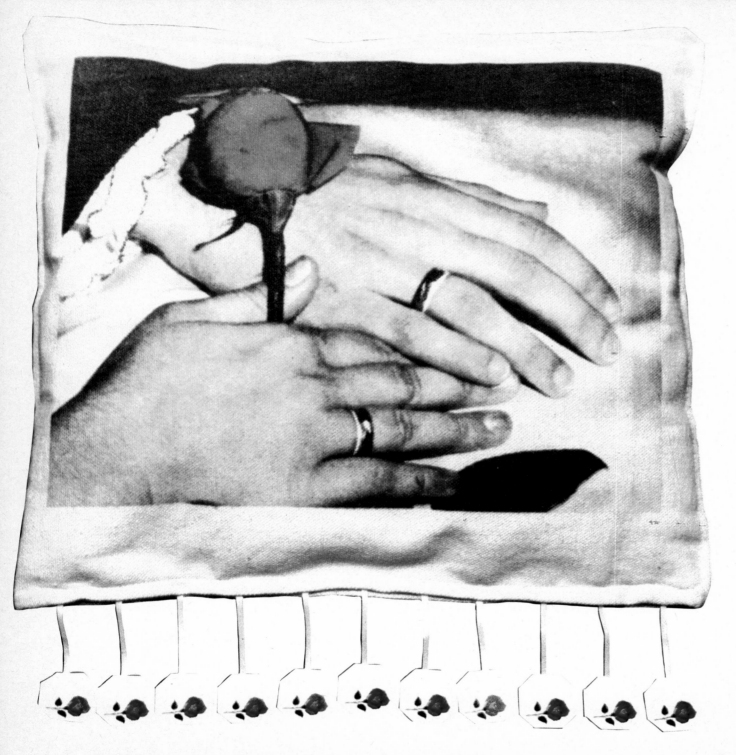

Herbert Edwards

"Tea For Two" (left)

1976, 3M Color-in-Color Copier, 11" × 12".

This was made from a photograph copied onto a heat transfer matrix and then pressed onto canvas. The canvas was then stuffed and made into a pillow. The ends of tea bags were then attached to the pillow.

"As a painter and photographer, I became interested in the unique qualities that the 3M Color-in-Color machine could achieve. It is more o a dye transfer process than an electro-static proces as the color Xerox. The 3M produces a softer, mor muted image. I've combined the copied images with other materials, or sewn them together to create single objects. I've seen the 3M machine as way to combine some of my photographic ideas with my painterly impulses."

Stephanie Weber

"Offering" (right)

1977, Etching, Painting, Xerox 6500 Color Copier, 20" ×

"In completing a work, I combine the image: the copy machine with other elements. Som I add traditional intaglio printmaking techniq using the copy machine as another printmak tool. I frequently integrate parts of the copy with drawing and painting in mixed media v The complete artwork is finally derived only consideration of a multitude of possibilities l alternative images, compositions and color designs."

Stephanie Weber

"Unfolding" from a series. (right)

1978, Xerox 6500 Color Copier, Drawing and Painting,
24" × 30".

Stephanie creates a great variety of images which
have subtlety and depth by composing objects
directly on the copy machine. She often places
colored acetate and textured fabrics or screens on
the glass window before arranging her compo-
sition. A composition might be developed from
such diverse objects as crushed tissue, fish, light
bulbs and, in this case, grapes.

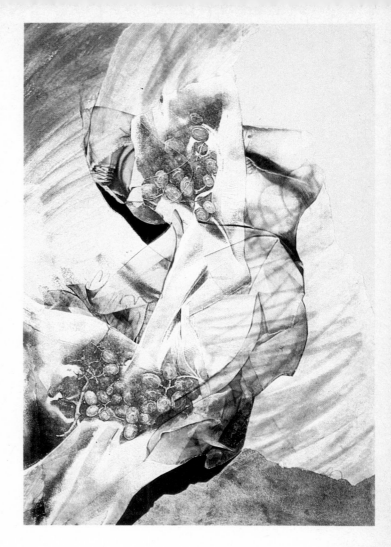

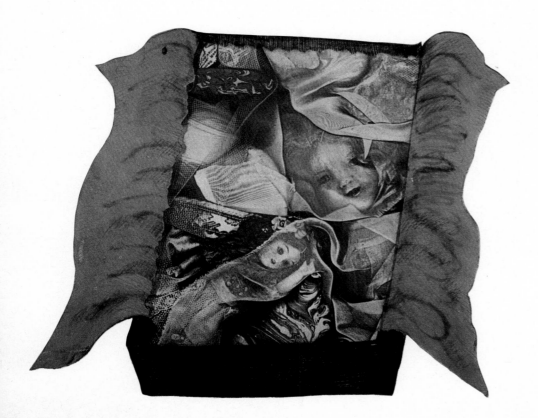

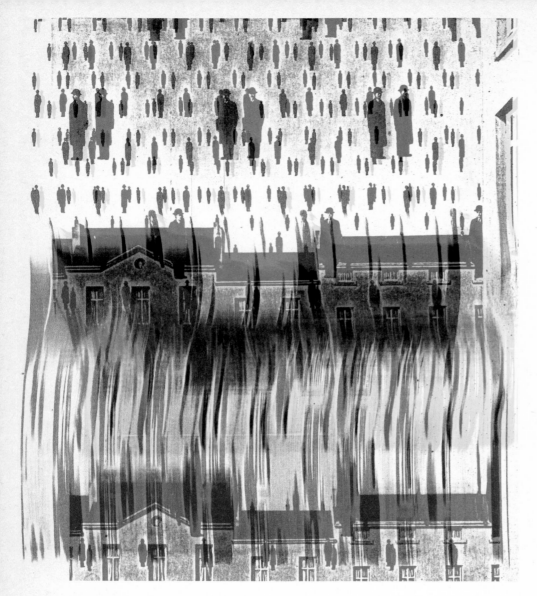

Stan Vanderbeek

Computer Generated Animation Film Frame (below)

1978, 3M Color-in-Color Systems I, 8″ × 10″.

The original art work was produced on a computer and is a frame from a computer animated film. The original black and white frame in 35mm was enlarged to a 8″ × 10″ negative and was color printed on a 3M Color-in-Color System I copy machine.

"I am interested in the prints that come out of my movies, and foresee the making of individual prints from the thousands of images in my movies as a reversal of time and process."

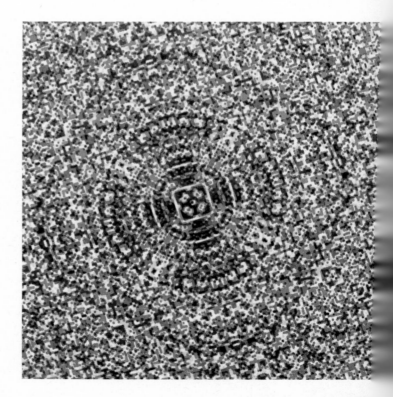

Claudia Katayanagi

"Homage to Magritte" (above)

1978, Xerox 6500 Color Copier, 8½″ × 11″.

"This is one of a series in a playful session with this René Magritte painting, "La Thérapeute" moving through Time and Space and copier colors."

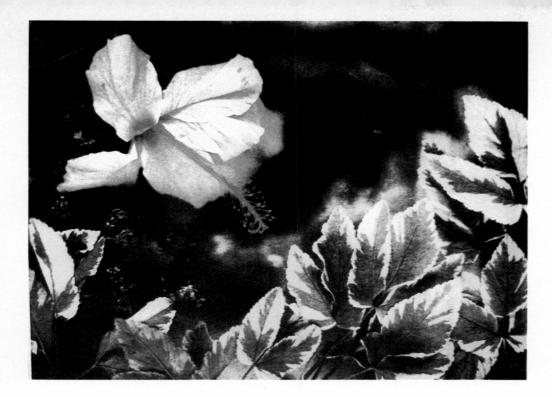

Sonia Landy Sheridan

"Thermal Plants via Sound", Slide courtesy: Diane Kirkpatrick. (below)

1971-73, 3M Dye Sheets and 3M Remote Facsimile Machine.

Thermal assemblage of weed on 3M dye sheets and fed into a 3M teleprinter

"Experiments combining the copy machine technology with devices to receive audio input are revealing unknown ties between sound and image. The addition of sound not only enlarges the image-making possibilities for visual artists, but it invites active participation by musicians."

Sonia Landy Sheridan

"Dying Plant Series", Slide Courtesy: Diane Kirkpatrick (above)

1976, 3M Color-in-Color Copier, 8½" × 11".

This image is number II in a series in which plants were printed successively with a 3M Color-in-Color machine by Sonia Sheridan as the plants were dying. This image was taken midway in the dying process.

"Because everyone can operate a copy machine, this technology democratizes the image-making process opening lines of communication between artist and viewer, and makes the act of creating an image less of a specialty.
This technology also moves aside the barriers between traditional art forms, for it assimilates into one medium other art forms including photography, printmaking and ceramics."

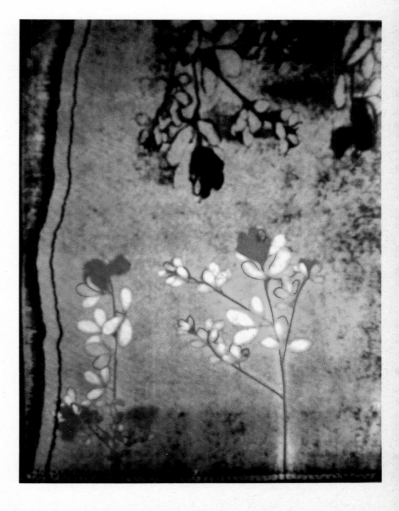

Jill Lynne

"Queen of Hearts Triptych"

1977, Xerox 6500 Color Copier, 3 Prints, each 8½″ × 11″.

This triptych utilizes the copy machine process to combine collage and montage techniques. The final collage image is printed on 2 separate, clear transparencies run through the Xerox 6500 and then a mylar sheet is placed under the two layered prints to give an added richness and a sense of depth.

"I believe that each individual image has to really stand on its own, whether it is part of a series or just on its own, whether it is part of a series or just one page in a whole book, and that each image has to be created with aesthetic integrity. I'm not just interested in the intellectual message to be communicated. I want to create beauty."

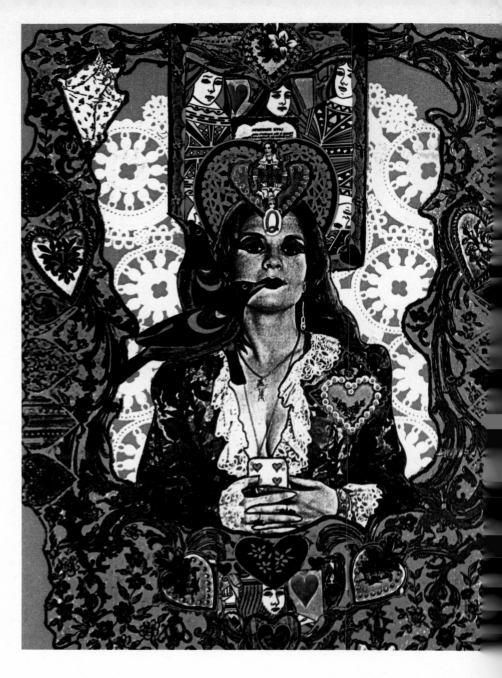

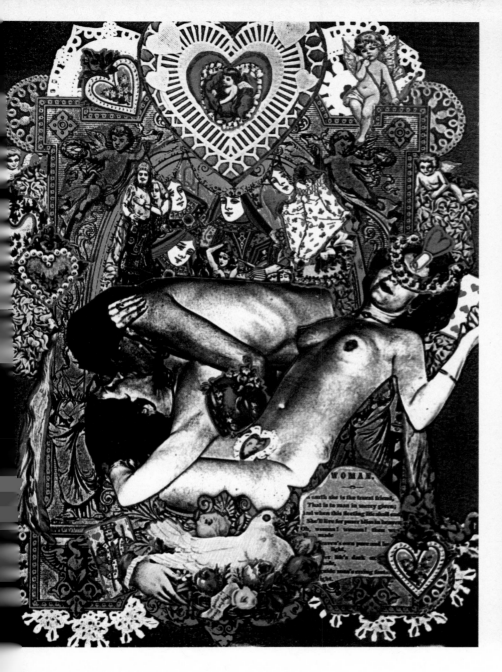

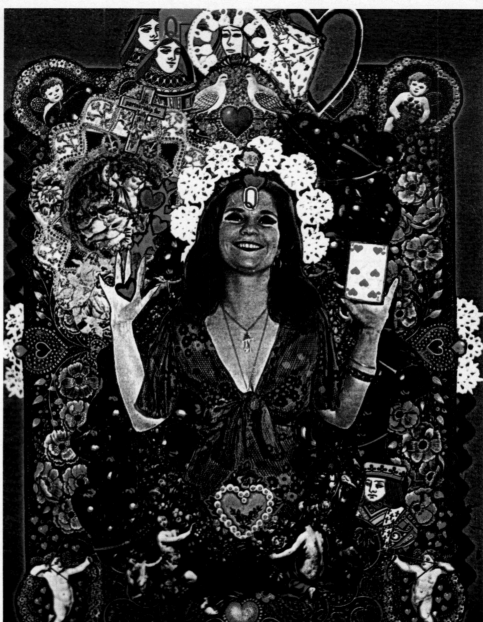

Rick, Ron and Stephen Globus

"The Pencil Mural Design with Ivan Chermayeff".

1977, "Globuscope®" and Computerized Electrostatic System,
Four Panels, Total Size, 8' × 54'.

With the Globus brothers' invention, the
"Globuscope®", a computerized scanning camera
can map surfaces of objects and environments on a
continuous, frameless strip of film. This 54 foot
photographic painting is blown up with a system of
photo-sensors and air brushes in their 360 degree
projection device which can project panoramic
images from one piece of film up to 150 feet in
length. This Pencil Mural is in the Parson Film
Auditorium in New York City.

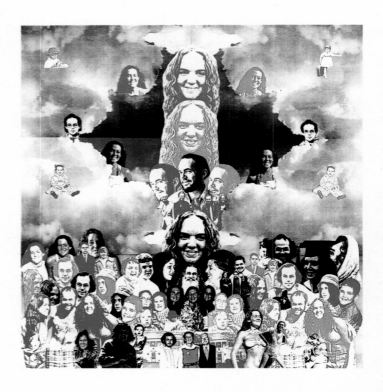

Lester Alexander

"Family Collage"

1977, Xerox 6500 Color Copier, 22" × 22".

"What can you give to parents who already have
everything? This collage took two days to lay out,
some more thoroughly enjoyable time rummaging
through old family snapshots, and about 30
minutes on the color Xerox machine. It was so well
received that I had to have photographic copies
made for other members of the family."

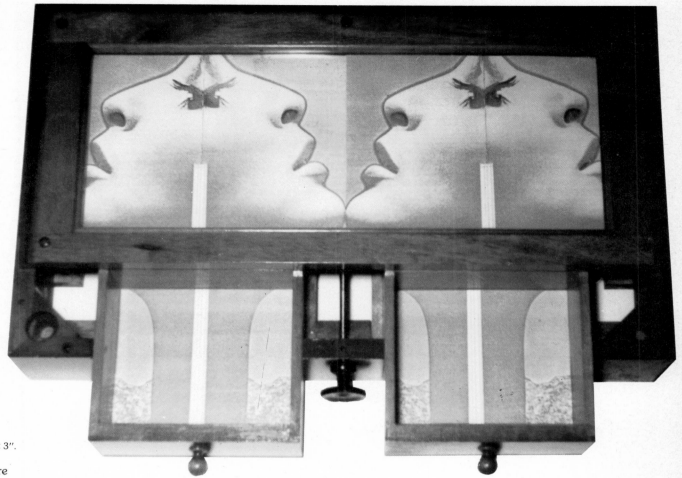

Tyler James Hoare

"Ladies Chest"

1975, Xerox 6500 Color Copier and Wood, 14″ × 18″ × 3″.

Tyler's sculptures or "mixed media" works are often constructions combining found objects and images. This mixed media example utilizes a color Xerox matrix image simply glued into this wooden piece.

Edward F. Higgins, III

"Travel Series" Postage Stamps (left)

1978, Xerox 6500 Color Copier, 8½″ × 11″.

Printed on Dryvac Gummed 60 pound paper and then perforated.

I collected stamps as a child and have been making postage stamps for four years now. As I remember, Doo-Da comes from a line in a Stephen Foster song, "Camptown Races" and connotes to me a happiness at working. Stephen Foster probably never picked cotton "all the live long day", so you better put that it comes from an old negro slave song. I am a slave to art at times, with definite leanings towards becoming a Xerox junkie. I have been utilizing the Xerox 6500 for printing stamps and assorted artworks. This facilitates creating numerous small run editions, with the possibility of sending color works to other artists."

Buster Cleveland

"Visual Poem for Ray Johnson" (right)

1977, Xerox 6500 Color Copier, 8½″ × 11″.

Xerox collage on graph paper.

"Everything is Art, but not everything is Dada."

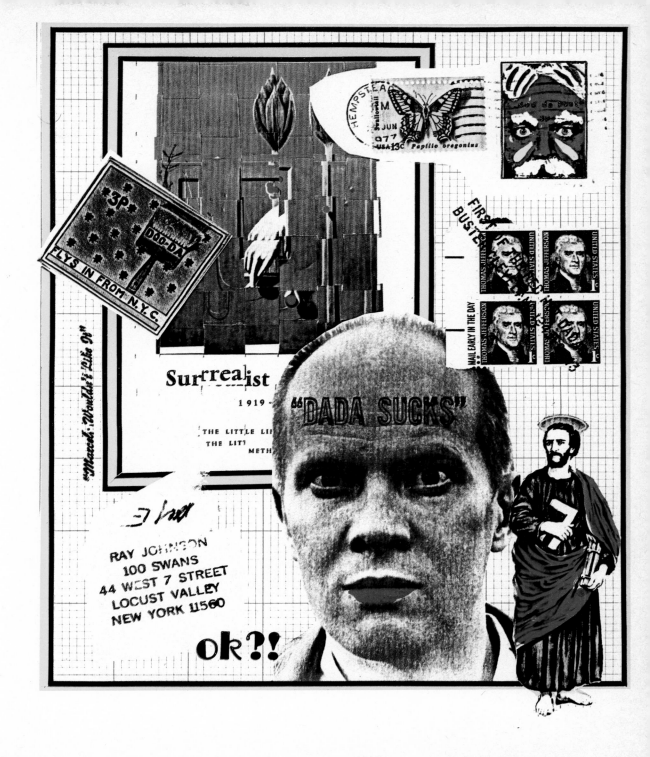

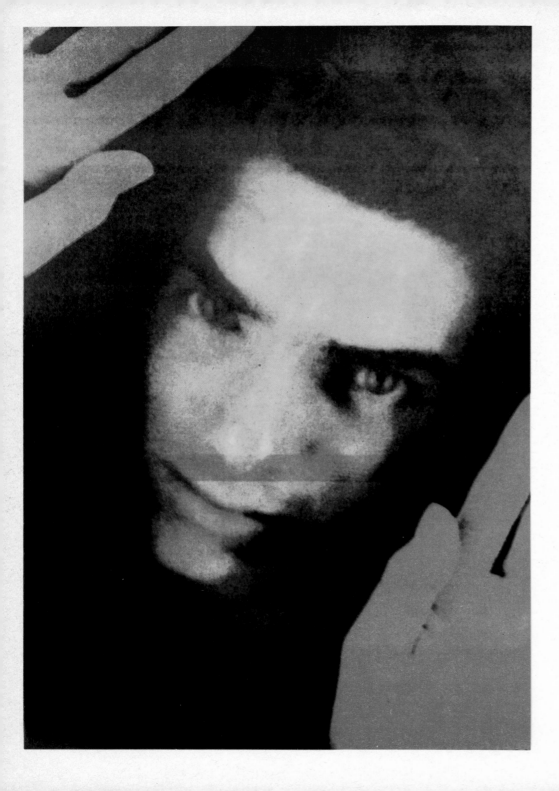

William Gray Harris

"Self Portrait"

1973, 3M Color-in-Color System I, 8½″ × 11″.

. . ."For the artist, the 3M Color-in-Color Systems offered the ultimate electronic palette. Composed of tiny granules of powder, the surface texture of 3M color prints resembles velvet. When viewed under artificial lighting this granular surface glitters subtly as it reflects the light source. When printed with care and regard to the sensitive technicalities —and it can take many trial copies before the proper density and color balance is achieved—a 3M color copy has all the qualities of a Fine Art Print."

Peter Thompson

"Self Portrait"

1977, 3M Variable Quality Copier (VQC) I and Multiple-Toned
Silver Print, 11″ × 14″.

This piece combines copier and photographic
techniques. Peter pressed his face on the 3M VQC
I template and sent the print through the machine,
solarized it with a bleach and redevelopment
process. A contact print was made on silver-based
photographic paper.

"I have an obsession for combining rational
thought with intuitive drives in what I call a "unitive
vision". I strongly believe it is no longer historically
viable to depend solely upon the intuitive, to
separate the conscious from the unconscious, the
scientific from the artistic."

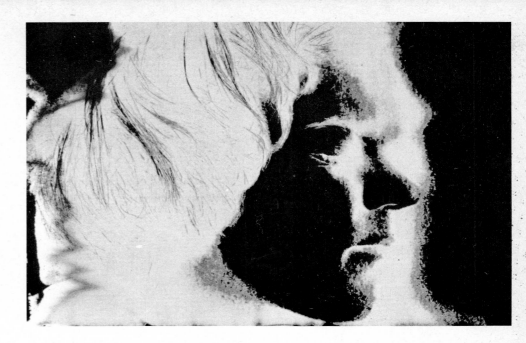

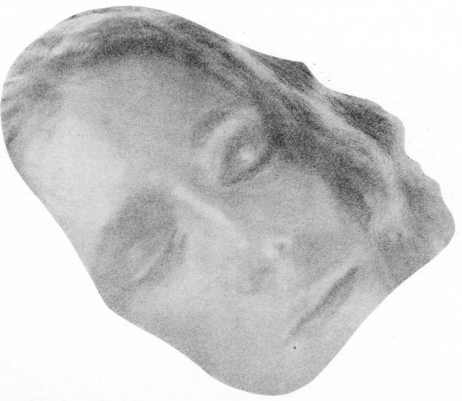

Susan Kaprov

"Dream"

1977, Haloid Xerox Monoprint, 10½″ × 14½″.

"Rather than use the Xerox machine for the
purpose of reproducing and/or elaborating upon
an identical image, I manipulate the machine by
actually dismantling it in order to achieve a highly
personal and intense imagery. In all my prints, I
attempt to achieve an incandescent quality of light
and a sensation of motion by using my hair as a
unifying element."

Margot Lovejoy

"Me, Again"

1978, Photo Montage and Xerox 6500 Color Copier,
8½″ × 11″.

Margot has created this piece by photographically
reducing the image of her face and then
manipulating the colors of the resulting montage
print on the 6500 copier.

Margot finds that since the color dyes of the
machine are covered with polymer and are
permanent, if the work is printed on rag support
paper, the resulting print is of archival quality.

Anna Banana

"Jealousy" (right)

1976, Royal Bond Copier I, 8½″ × 11″.

This print is from a limited edition, of different
works created on what Anna feels is the best copy
machine in terms of giving crisp copies of both line
and half-tone black and white material. Many of
Anna's works, done in conjunction with her Mail
Art are hand-colored in yellow, as in Banana.

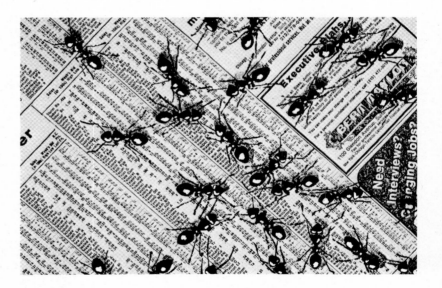

Leland Fletcher

"Executive Blahs"

1977, Xerox 6500 Color Copier, 8½″ × 7″.

This is the first page from the book entitled
American Exchange, printed as a limited edition for
the Los Angeles Institute of Contemporary Art.

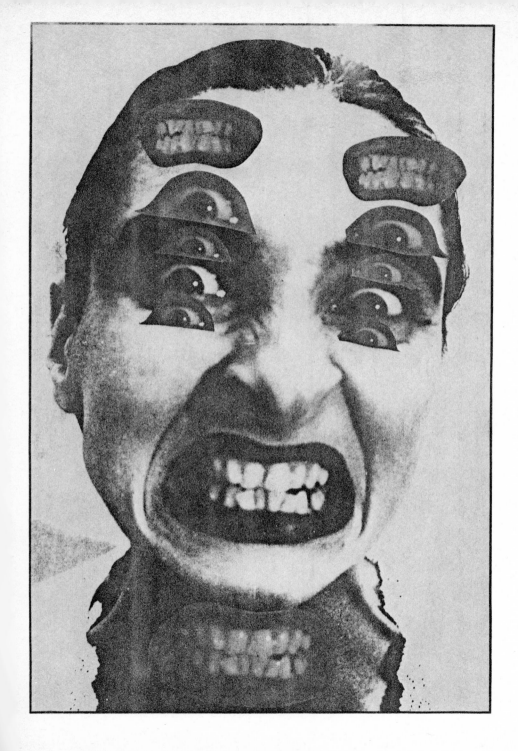

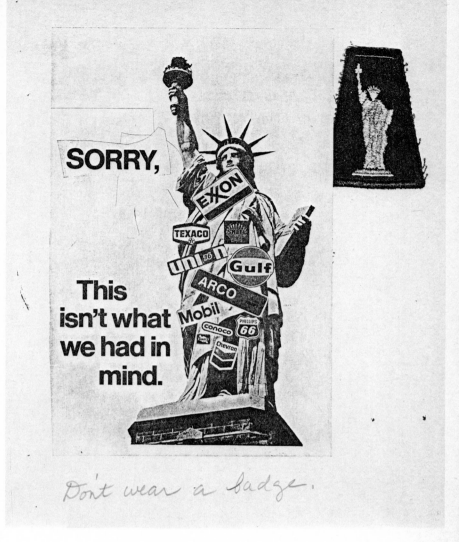

Don't wear a badge.

Marcie-Kristen McClure

"Sacri-Liberty: A Primer on Being A Big Woman"

1977, Xerox 6500 Color and 3107 Black and White Copiers,
8½" × 11".

This piece was created first as a paste-up and then
copied and put into book form. A heat transfer of
the Statue of Liberty in collage form was included
in the limited edition. Marcie notes that "On
October 8 of this year (1977), the largest female in
the U.S. turned 91."

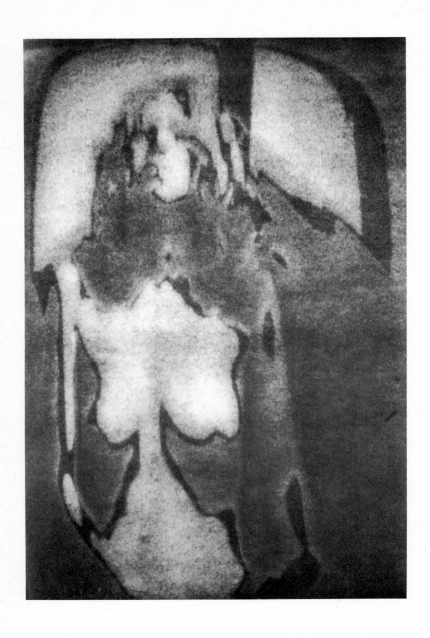

Thomas Norton

"Electrographics"

1976, 3M Color-In-Color Copier & Video, 8½" × 11".

Tom Norton uses a combination of a 3M color copier and a video system which includes a black and white video camera and a television screen to produce a wide range of vivid images on paper. The video camera picks up an image on the tv screen which is introduced to the copier. The image is then transferred to paper. The addition of colors takes from 45 seconds to 10 minutes. The video system was designed by Dr. Robert D. Solomon of Solotest Corporation.

Peter Thompson

"Phases"

1977, 3M Variable Quality Copier I, 8½" × 14".

This plant is simply laid on the copier template.

Peter Thompson

Print #13.9 From Unit 13,

1977, 3M Remote Facsimile Telecopier, 8½″ × 11″.

"I put the reproduction of a cliché-verre by Brassaï into the 3M remote facsimile along with a piece of blank white paper. The facsimile was linked to a second, remote facsimile by means of two old desk telephones connected to a 12 volt battery to make them conduct an audible signal. I purposely made the second machine out of synch with the first by opening the top and mis-registering the little mirror to the right of the revolving drum. The physical effect was a mis-registration of the print, causing the beautiful bottom horizon. As the image was transmitted, I used the pinch-editing device located at the top of the machine—either to omit or re-image parts of the original, or to hop to the blank paper in order to make white space in the print."

Tyler James Hoare

"McCal"

1975, 3M Color-in-Color Copier, 30″ × 30″.

This piece was created by MATRIXING one
original image and then covering the finished
assembly with clear plexiglass.

COPY CRAFTS

THE BASIC TECHNIQUES

As in any medium, there are a few basic *Copy Art* techniques upon which everything else is based. In many media, these so-called basic techniques are sufficiently difficult to discourage many of us from participating. Sometimes, they are also very expensive.

Copy Art requires little or no capital investment and the basic techniques are limited in number and very simple. We will take you through them quickly first and then stir up your creative thoughts with some of their applications. And that's really what *Copy Art* is all about—imagination and application.

Just when we find ourselves getting jaded, thinking that we know all there is to know, and that we have finally assembled the definitive collection of *Copy Art*, in will walk someone with something so unusual, beautiful, and usually very simple that we again realize that there are no creative limitations to what can be done with these machines that are all too often taken for granted as mere business tools.

Copy Art does impose its limitations, however, and they can prove to be both a frustration and an inspiration. You are, first of all, limited by the overall image size. On most machines, this is either standard letter (8½″ × 11″) or legal (8½″ × 14″) format.

Certain copiers such as the Xerox 3107 will accept larger originals up to 14″ × 25″ but these machines aren't easily found. The way around this limitation of size can be found in our sections on MATRIXING and HEAT TRANSFERS.

Other limitations include clarity of image, focus, resolution, contrast, and, in the case of color, the spectrum you have to choose from. With the Xerox 6500 color copier, you have seven different color combinations to choose from. The 3M Color-In-Color system offers you twenty-seven. Design limitations of the various machines will become apparent to you as you

start working with them. *Copy Art* is, in a way, like haiku or a sonnet. It imposes its own discipline.

You will realize, as we did very early on, that these machines represent a young and primitive technology. The inside of a 6500 color copier looks like a Rube Goldberg contraption complete with wheels, levers, drums, belts, lights, and funny noises that go "bump" in the dark! It's far too crazy and complicated to be really sophisticated but, somehow, it works.

The truly wonderful thing about *Copy Art*, though, is the instant gratification. Lay your material down and, thirty seconds later, it comes out finished. Instant art is born. Quicker, even, than Polaroid you are able to see and evaluate your work, make the necessary adjustments to the machine, and then start again.

Art and technology merge with crafts into what Sonia Landy-Sheridan chooses to label "homography" and what we call *Copy Art*. As we see it, *Copy Art* is anything that has been created, transformed, or enhanced through the use of a copy machine.

One of our most requested pieces of *Copy Art* is called "OBJECTS" (you can see it in the color art section) and it's nothing more than just that—some simple objects placed on the color copier.

We have included a wide range of *Copy Art* crafts and techniques—ranging from the very simple and fast such as "OBJECTS"—to some of the very elaborate and meticulously crafted works by our contributing artists. So, first the basic techniques and then their applications. By the time you have finished this book, we are sure that you will never again look at a copy machine in quite the same way.

FLATWORK

The first technique is so simple that it hardly warrants mention as a technique at all. Place your image on the machine of your choice, press the button, and you're in business. Most of the newer dry toner, plain paper copiers on the market can produce clear, perfect copies. Be finicky. If you have an office machine, clean it regularly, check the supply of toner, and if your copies still aren't good, call the copier company and holler.

When you go to a copy store, ask to see a sample of what their machines can do. Most stores have a number of different machines and it's usually worth the extra minute to see which one gives the best results. We have found that the high-speed machines such as the Kodak Ektaprint and the Xerox 9200 generally do the best job of reproducing black and white photographs. They are also much more forgiving of scotch tape and shadow lines. Oftentimes you won't see them at all on your copy.

The newest Minolta copiers give greater contrast and a very rich black and white image. Canon copies are generally sharp, as are those made on the small Xerox 3100 and 3107 (when the machines are clean and well-maintained). The IBM copiers we have worked with have reproduced spots, dots of light, and streaks. On long copying jobs, the smaller machines have a tendency to overheat which lowers the overall quality.

If you're doing a large job, find a machine which will do your collating for you. The best collating devices we have found are on the Xerox and Canon machines. Kodak has a collater on its Ektaprint that is vicious. Be wary of it. It works by recirculating your original sheets over and over again in sequence

and is a very hungry machine. It eats originals.

Flatwork on the Xerox 6500 color copier is more difficult. You probably won't get the colors you want on the first run through the machine. You will no doubt, unless you are lucky or rich, have to deal with a copy shop *employee* who will be making the actual adjustments to the machine. Good luck!

Befriend your local copy shop employee!!! These people are usually harried and harassed. Let them know that you are working on something special, that you are something of an aficionado, and, most important, that you are willing to come back when they can devote some time and attention to your work.

We wish we could give you simple rules that would guarantee a perfect color copy *every* time but the machines differ so widely among themselves that the optimum setting on one might not work at all on another. If you plan on doing a more complicated project, ask about booking the machine for a certain period of time—say 30 minutes.

If not, plan out your copying in advance as clearly as you possibly can. Your instructions to the copy shop *employee* will have to be clear, precise, and step-by-step. Avoid describing the finished result you're looking for and asking the *employee* to get it for you.

Read the appropriate section of this book, figure out what *you* think needs to be done, and then tell them to do it. You will have to learn some things by experimentation. There's just no way around it. There is no substitute for experimentation in *Copy Art.*

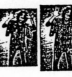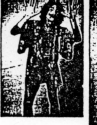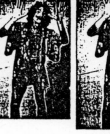

REDUCTIONS AND CORRECTIONS

Several of the black and white copiers currently on the market will make reduction copies of standard size originals. Different machines reduce according to different proportions and some have a much greater flexibility than others.

The Xerox model 3107 enables one to copy an image up to 14″ × 25″ and then reduce it. Several companies now have machines which will reduce an image in increments of up to two-thirds. By reducing a reduction copy and then repeating the process again and again, you can shrink an image as small as you choose with a corresponding, but oftentimes interesting, loss of quality with each successive generation.

The best black and white reduction copiers we have worked with are those made by Kodak and Xerox. Several other companies have announced plans to introduce black and white reduction copiers of their own. Watch for them.

It was the reduction process, back several years ago, that started us thinking about creative uses of copying machines. After turning out countless similar looking proposals for various projects, we began to wonder what could be done to spruce them up and give them some visual "punch".

First attempts consisted of taking standard pages of typewriter type, reducing them, and then copying these reduced pages onto a sheet of 8½″ × 11″ paper turned on its side. We now had horizontal instead of vertical proposals.

Before long, we realized that a very neat way of inserting graphs or quotations onto our pages would be to reduce rather than indent. Take the graph or quotation of your choice and reduce it by one setting on whatever machine you have access to. Using a razor blade or matte knife, cut out the

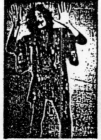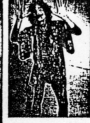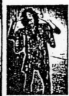

Steven Mendelson

"Self Portrait"

1977, Photograph, Transparency, Xerox 9200 Copier and Blue Print Machine, 8½″ × 11″.

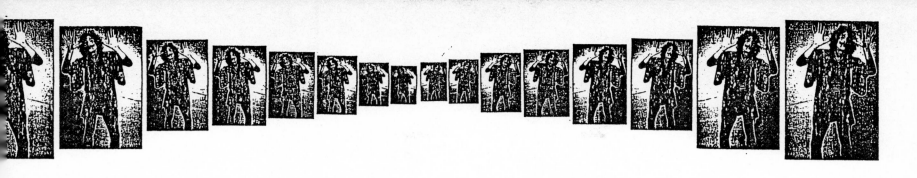

reduced graph or piece of text and lay it on your original page using either rubber cement or clear "magic" tape. Finish typing the page and then make a normal copy of it.

If your copy has a "shadow line" around where the reduction was fastened down, you have several alternatives. The first is to go back to the original page, take some "white out" fluid, and apply it around the edges of the reduction. If you make a copy and still have a shadow line, all hope is not lost.

Your next step is to obtain some white out fluid for copies. DO NOT USE CONVENTIONAL "WHITE OUT" ON A COPY! It dissolves the toner used in most dry copy processes and will smudge and ruin your copy. "White out" for copies is a basic office necessity that most offices are without.

On as clear and crisp a copy as you can make, use the white out for copies to eliminate the shadow line. Take this corrected copy and make a copy of it. The result should be perfect.

This same technique, incidentally, is a wonderful timesaver when you want to take paragraphs from several different pages or drafts and combine them onto one neat page. Cut out the desired paragraphs or pictures, line them up on a clean, white page so that the margins match, and fasten them down. Use one of the processes described above to produce a perfect copy.

NOTE: The glass plate on most copiers with a reduction capability will usually be larger than the original you want to copy. Place your original face down on the plate and cover it with a piece of cardboard that also covers the entire glass plate. Failure to do so will result in a messy black line border on your reduced copy.

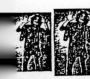
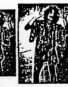

The original photograph was successively reduced on the Xerox 9200, arranged in the pattern shown, and transferred to a transparency. The transparency was then contact printed on a Blueprint machine.

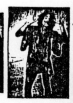
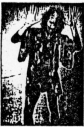
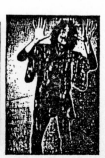

SLIDES

One of the wonderful things about the Xerox 6500 color copier and the 3-M Color-In-Color System II, copier are their ability to copy slides. The slide adapter for the 6500, the more readily available of the two machines, is nothing more than a bracket attached to the side of the machine designed to hold a standard carousel slide projector. The slide projector is aimed at a small mirror which swings over the machine. This mirror then reflects the image onto a special plastic lens assembly which fits over and covers the document glass.

The slide projector has a moveable color correction filter pack which is flipped in front of the lens while you are making the actual copy of your slide. It can then be flipped away while you focus. Most of the projectors you are likely to encounter at copy shops will come equipped with a zoom lens which will let you crop your slides instantly by zooming in on any area of the image. Cardboard masks of almost any shape can also be placed under the plastic lens assembly. They will provide an instant "frame" for your copy.

The actual process of making a slide copy on the 6500 color copier is easy if you remember the following simple steps:

1) Place your slide in the projector (understanding that the final copy will be a flipped, mirror version of what you actually *see*).
2) Place the lens assembly over the document glass.
3) If you are going to use a mask, place it under the plastic lens assembly.

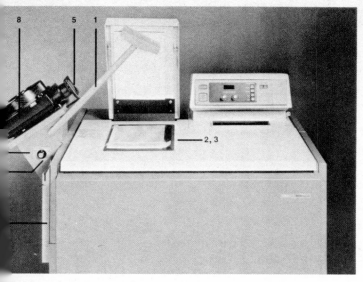

·or Arm Assembly Supports the mirror at the correct angle to reflect the projected slide image onto the document glass.

k Positioned by the operator on the document glass. Creates a white frame around the slide image.

·tic Lens Assembly Positioned by the operator on the document glass over the mask. The Plastic Lens directs the focused light image from the projector into the optics of the color copier. The dot screen (attached to the bottom of the plastic lens) reduces the contrast of the projected slide image for better color rendition.

·e Brightness ·rol Controls image brightness by regulating the light output from the projector. Enables the operator to compensate for variations in slide density (too light or too dark) and magnification.

· Pack Balances the illumination system of the projector with that of the color copier to provide accurate color rendition on copies made from slides.

·Assembly Supports the projector in correct position on the copier.

·ge Pocket Provides convenient storage for the Plastic Lens Assembly and masks.

·Projector ·lied by Customer) Projects the slide image onto the mirror where it is reflected onto the document glass.

4) Cover the lens assembly with a piece of white paper or cardboard so you can focus accurately.

5) Zoom in on the exact portion of the slide you wish to copy.

6) Set the three color controls at the maximum settings. The slide projector dimmer control, known as the "Brightness Controller," should be set at the normal setting. If your copy is too dark and the "Brightness Controller" cannot lighten it up sufficiently, you can turn down the three color controls together to achieve a similar effect. A particular color can be highlighted by lowering the settings for the other two colors. Remember that the color machine functions on a subtractive system. That means that you turn your knobs down to add more of a particular color.

7) Eliminate as much ambient room light as possible.

8) Move the filter pack in front of the slide projector lens. If you forget to do this, your copy will be very yellow and "washed out".

9) Remove the sheet of paper you used to focus your slide. (If you forget to remove this sheet of paper, you will get a copy that has a solid black area where your slide image should be).

10) Make your copy.

Superimposition

Overlays

SUPERIMPOSITIONS AND OVERLAYS

By using the slide adapter on the 6500 color copier, a transparency image can be superimposed over a projected slide image. The transparency is placed face down between the mask and the plastic lens assembly. The slide image is then projected through the mask in the normal manner. The result is a composite copy which depicts both the projected slide image and the superimposed image. (NOTE: You can also use the machine to create your own transparencies. See TRANSPARENCIES.)

An overlay involves the superimposing of opaque material over the projected slide image. For example, if a heading is laid face down on the document glass between the mask and plastic lens assembly, and if the slide image is projected through the mask, the composite copy will depict the heading overlaid on the slide image.

Finally, a thin sheet of tinted or patterned plastic (gel) can be inserted between the mask and the plastic lens assembly. When a slide image is projected through the mask, the plastic will create a colored tint or pattern over the entire copy.

Courtesy Xerox Corporation

Place your hand in front of the filter pack during the scan which prints the color you want for the white areas. If the mixed color selected was blue, block the filters during either the first (magenta) or third (cyan) scan of the copier.

CONVERTING BLACK AND WHITE SLIDE IMAGES TO COLOR

The black portions of a black and white slide image can be converted to color by choosing any combination of color buttons EXCEPT Full Color. The black areas on your copy will reproduce as the color you selected. The white areas will remain white.

The white portions of a black and white slide image can be converted to color by, once again, choosing the color you wish to substitute for white. The key to this process is knowing that the 6500 prints color scans in this order: Magenta, Yellow, and Cyan.

Press the Full Color button and then block the slide projector with your hands before the scan or scans which produce the color you want. For example, if you want white to print as magenta, block the projector before the magenta (first) scan. The white areas on your copy will reproduce as magenta. The black areas will remain black.

By combining these two techniques, you can convert any black and white portions of a slide image to color.

Other Photographic Transparencies
Besides the 2″ x 2″ 35 mm slide, any photographic or color diazo transparency up to an 8″ x 10″ original can be placed on the document glass and copied size-for-size, using the projector to provide backlighting for the transparency. In addition, all applications for slide copying described in this section can also be used with larger size transparencies.

TRANSPARENCIES

Most copiers, we discovered, will accept transparencies in place of paper. "So what?" you might ask. Well, what this *Copy Art* technique means is that anything you would normally copy onto paper can now be reproduced on clear pieces of acetate.

Perhaps a self-created stained glass window would look nice somewhere in your home or on your car. By combining several of these transparencies through matrixing (see MATRIXING), it is possible to cover large areas of glass or plexiglass with images of faces, clouds, water patterns, flowers, or any other texture that catches your fancy.

Plexiglass panels with transparencies mounted on them can be used as room dividers. A sheet of plexiglass covered with transparencies and mounted in front of a small lamp can serve as a simple light box while several pieces of plexiglass fashioned into a small box can serve as a box lamp or night light.

We have found that the most striking transparencies are those produced on the 6500 color copier but black and whites can be fun and are a good and inexpensive way to get more familiar with the process. Speaking of the process, it's not always foolproof and we recommend looking through the instruction manual for the particular machine you will be using before actually attempting it.

It's usually advisable to leave some paper in the loading tray of your machine and to place the individual transparency on top of this paper.

Finished transparencies should be handled with care as the toner from your copier is not absorbed into the film. This means that if you scrape the surface of your transparency, some of the image can come off. You can use this to your advantage by taking some tetrachloroethylene (perchloroethylene), a solvent that removes toner, and wipe off any portions of the image not to your liking.

Conversely, new data can be added to your transparency with an ordinary grease pencil or a solvent type marking pen. Finished copies from the 6500 color copier must go through an additional step known as fusing. They are placed in a sealed compartment filled with trichloroethane which fixes the image onto the film.

NOTE: Transparencies cannot be made on the 6500 color copier unless the special "transparency" card is first placed in the loading bin. This card activates a cut-off device which turns off the heat fuser. If you don't do this, you will end up with a melted piece of plastic.

HEAT TRANSFERS

Heat transfer paper is one of the easiest ways of applying images onto a wide assortment of surfaces—fabrics, glass, plastic, wood, tiles, and different kinds of paper—just to name a few. Heat transfers are most widely associated with the T-shirt craze. You go into a store, select the heat transfer image of your choice, and they iron it on to your T-shirt.

Copy machines now let you design your own heat transfers. The process is easy. Sheets of heat transfer paper are loaded into the copy machine instead of conventional bond paper. As with transparencies, it's best to load them one sheet at a time. The finished heat transfers are then simply ironed on to the desired surface.

For some reason, blank heat transfer paper is not easy to come by so don't expect your local copy shop to have it on hand. Call in advance to see if they do. If not, calls to one or two local paper supply companies should locate some for you.

Another of their advantages is that the actual designing and application of the transfer to the surface can be done in your home. All the work that needs to be done at the copy shop is the relatively simple task of making a copy. If your color copy center has a machine with the contrast control, it provides interesting results when you lighten your copy on the heat transfer. Remember, however, that the contrast control is activated only when the document cover is in the *down* position.

When using the 6500 color copier, make sure that the card used for transparencies is placed in the paper tray. This will deactivate the fuser. Run the transfer paper shiny side *down*.

SOME ADDITIONAL BUSINESS
USES OF THE COLOR COPIER

Catalog sheets of fabrics, floor covering, jewelry, wallpaper, etc.

Multi-colored graphs and charts

Overhead projection transparencies

Schematics

Previews of color-printed literature

Maps

Copies of slides shown during presentations

Illustrated price lists

Advertising and book proofs

Properly used, color can be very effective to:

- Gain immediate attention
- Highlight important data
- Clarify complex information
- Emphasize critical facts
- Speed information retrieval
- Reduce possibility of errors and misinterpretation

APPLYING COLOR TO TEXT

For rapid response, priority information can be quickly circled, boxed, underlined, or overlaid with color. The basic tools are a highlighter pen, a fine line magic marker, color typing film, and color graphic film (the last two items are used to overlay and color in large blocks of text). This becomes especially useful to uncover facts not apparent in text or tables and to aid in interpretation of computer-generated reports.

Different drafts of a letter or text can be copied in different colors for easy reference. For example, the original letter would be done in black and white. The first draft might be copied in magenta, the second in cyan, and the final version back in black and white.

Troubleshooting Guide

Problem	Cause	Corrective Action
1. Black border around one or more edges of image.	Slide image not aligned properly with mask.	Project slide image through mask so it overlaps mask on all four sides.
2. Black border on edge(s) of copy.	Mask not positioned correctly on document glass.	Position mask in top right corner of document glass.
3. Very light copy (poor color reproduction).	Color adjustment controls not set at maximum clockwise position.	Set color adjustment controls to setting (5).
	Color Adjustment Control Key not in horizontal position.	Turn Color Adjustment Control Key to horizontal position.
4. Dark or distorted copy.	Incorrect positioning of plastic lens.	Reposition plastic lens assembly in clips along left side of the document glass.
5. Black copy.	Focusing paper not removed from plastic lens.	Remove focusing paper from lens.
6. Dark areas (shadows) on edges of copy.	Filter pack not properly aligned with projector lens.	Align filter pack so light is projected through center of filters.
	Zoom lens is not set at maximum position when backlighting.	Set zoom lens to maximum (102 mm) position.
7. Specks, blurs or smudge.marks on copy.	Dust, dirt or smudges on document glass, screen, plastic lens, projector lens or slide.	Clean document glass with Xerox Lens and Mirror Cleaner; clean other surfaces with camel hair brush or air brush.
8. Streaking on copy.	Dirty scorotron.	Clean scorotron (see 6500 Color Copier Operator's Manual).
9. Image on copy is skewed.	Projector not levelled.	Elevate rear leg of projector until image is projected evenly through mask.
10. Copy shows image backward.	Incorrect positioning of slide in projector.	Reposition slide in projector so image appears backward on focusing paper.
11. Double image on copy.	Color Copier, Slide Adapter or projector has been jarred during operation.	Do not lean on or bump against copier, Slide Adapter or projector.
12. Blotches on copy.	Obstruction in light path (e.g., hand).	Remove obstruction from light path.
13. Image on copy out of focus.	Focusing dial on projector not adjusted properly.	Lay sheet of focusing paper over plastic lens and refocus image.
	Incorrect positioning of slide in projector.	Reposition slide in projector so image appears backward on focusing paper.
	Incorrect positioning of plastic lens assembly.	Reposition plastic lens assembly in clips along left side of document glass.
14. Inability to focus.	Incorrect positioning of plastic lens assembly.	Reposition plastic lens assembly in clips along left side of document glass.
15. Copy out of focus on edges.	Image was focused at center only.	Refocus for best result over entire image format.
		Reduce image size.
16. Copy out of focus at center.	Image was focused at edges only.	Refocus for best result over entire image format.
		Reduce image size.
17. Projector or lamp does not come on.	Power interruption.	Check power cord connections. Check reset button Check power switch
	Lamp burnt out.	Check projector lamp.

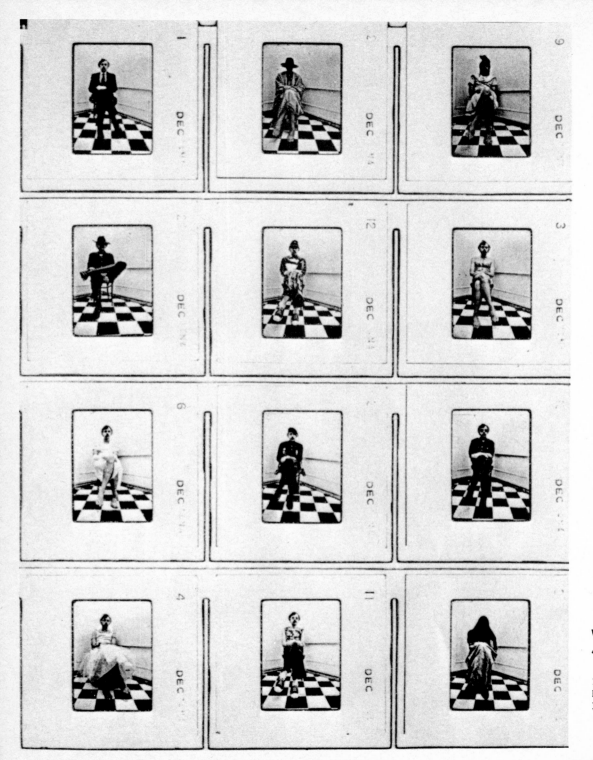

William Wert

"Proof of David's Portraits"

1978, 35mm Slides of
David Nunemaker on
Xerox #6500, 8½″ × 11″.

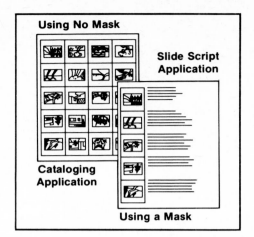

Using No Mask

Slide Script Application

Cataloging Application

Using a Mask

2. Backlighting (Set zoom lens to maximum 102 mm position).

Multiple Slides

Slides can be placed face down on the
document glass, on top of either the slide
mask supplied by Xerox, one made from a
blank mask, or without a mask.

Lower the plastic lens assembly on top of the
slides. When the projector (without a slide)
is turned on, the light projected onto the
plastic lens illuminates the slides so they can
be seen by the Color Copier. The result
is a size-for-size copy of the slides placed on
the document glass.

Masks can be created for many purposes, including the following:

To frame images projected from non-standard size slides.

To crop out non-essential elements.

To frame irregular shaped portions.

To add text or color for copying along with the projected slide image.

Illustrations Courtesy Xerox Corporation.

1. Masks
Besides being supplied with 3 precut masks in the most commonly used dimensions, you have also been provided with 6 blank masks. With these blanks you can tailor-make your own masks to fit your particular cropping and framing needs. Simply cut out the size and shape you desire.

CATALOGING SLIDES

One of the major inconveniences of color slides is the problem of viewing them without a slide projector. Until now, the alternatives consisted of cumbersome viewers, expensive light boxes, or simply holding the slides up to a lamp and squinting at them.

Using the backlighting capability of the 6500 color copier, you can create quick and inexpensive proof sheets of all your slides. These sheets can then be placed in a loose-leaf binder for easy viewing, while your originals are kept dust and fingerprint-free in your files.

To backlight slides, place them face down on the document glass and set the zoom lens on the slide projector to the maximum (102mm) position. Lower the plastic lens assembly on top of the slides and turn on the slide projector (with its slide gate empty). The light projected onto the plastic lens assembly will illuminate the slides so they can be seen by the copier. The result is a size-for-size copy of the slides.

A further convenience is the ability to mask slides in a number of ways. Masking enables you to frame images projected from non-standard size transparencies, to crop out non-essential elements, to frame irregular shaped portions, and to add text or color for copying along with the slides.

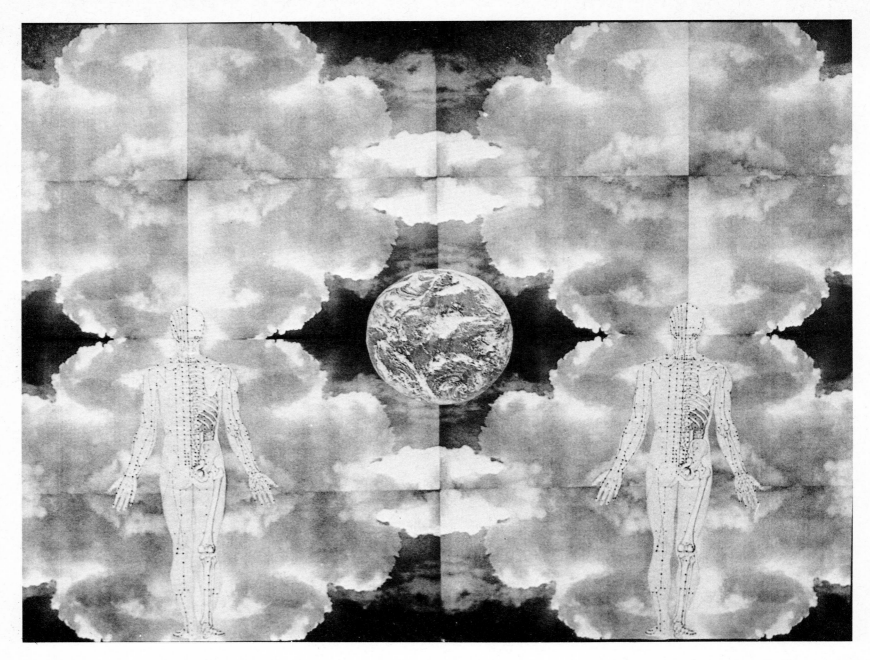

Patrick Firpo

"Looking at His Own Universe"

1978, Collage and Color Xerox Matrix, 24″ × 32″.

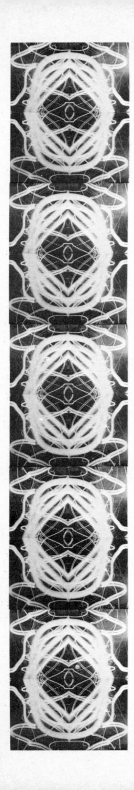

Steven Mendelson

"Yolaine"

1977, Photograph, Transparency, Xerox 9200 Black and White Copier and Blueprint Machine, 8½" × 11".

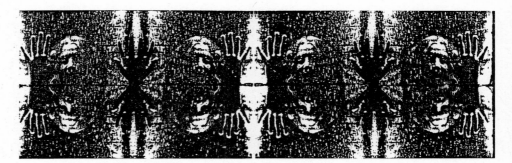

MATRIXING

Matrixing, or mirror imaging, is a way of using the slide duplicating capability of the 6500 color copier to create *Copy Art* works which are larger than the standard 8½" × 11" or 8½" × 14" copy format. A two image matrix is created by making a copy of your original slide, then turning the slide around in the slide projector and making a copy of the reverse image.

These two copies can then be placed side-by-side, creating a mirror image of the original. A four image matrix is created by making two copies of each image and matrixing them. There is no limit to how large a finished piece you can construct with this method. Matrixing is especially useful when creating fabric design, tiles, wall paper and anything requiring a symmetrically repeating pattern.

Anita Steckel

"Creation Revisited"

1977, Collage on Xerox 6500, 8½" × 14".

This is just one image from the larger work by the same title, comprised of multiple collage and color Xerox prints. Anita's winged, mythic image appears flying amidst Michaelangelo's "Creation" in the Sistine Chapel.

"It's really important for women to remake history and see themselves as acceptably part of history since they have been excluded or diminished by male written records. My recent work reflects spiritual and political freedom meshed with art freedom."

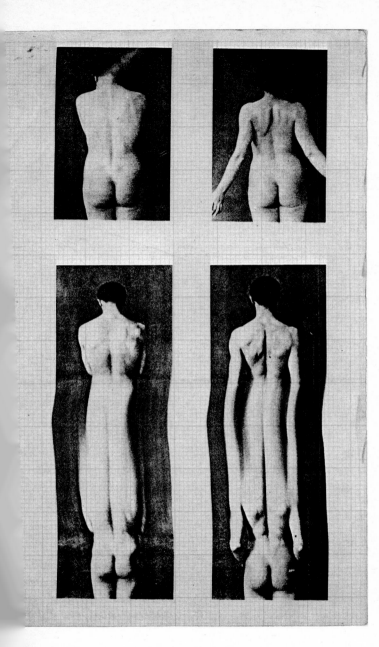

Maura Sheehan

"Egress"

1975, Xerox 2000, 8½" × 14".

This image was moved while
it was being copied and
then was transferred
onto graph paper.

Aldo Tambellini

From *"Hand Series"*

1977, Xerox Black and White, 8½" × 11".

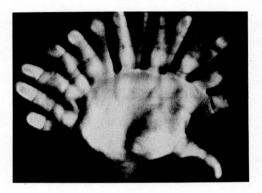

COPY MOTION

One of the first things one observes when making a copy is that, if the machine or the original image moves, the copy fuzzes, blurs, or ghosts (a secondary image appears on the borders of the first). Copy enthusiasts have begun to utilize this function and exaggerate it in order to create the "copy motion" pieces as shown here.

In most of the slower speed machines that you are likely to find in a smaller office, a "light bar" scans the original image. This does not happen on machines such as the Kodak Ektaprint and Xerox 9200 which use strobe "flash" lighting (see the description of this in the opening section, "A Quick Guide To Copying Processes").

On the slower black and white or color machines, the original image can be moved with the "light bar" as it completes its scan. The most dramatic effects, however, are accomplished on the 6500 color copier which scans each original three times, once for each color. The "copy motion" effect on the color machine is, in many cases, unpredictable and breathtaking.

(See *"Homage to Magritte"* by Claudia Katayanagi in the color art section.)

```
ABCDEFGHIJKLMNOPQRSTUVWXYZ
ZABCDEFGHIJKLMNOPQRSTUVWXY
YZABCDEFGHIJKLMNOPQRSTUVWX
XYZABCDEFGHIJKLMNOPQRSTUVW
WXYZABCDEFGHIJKLMNOPQRSTUV
VWXYZABCDEFGHIJKLMNOPQRSTU
UVWXYZABCDEFGHIJKLMNOPQRST
TUVWXYZABCDEFGHIJKLMNOPQRS
STUVWXYZABCDEFGHIJKLMNOPQR
RSTUVWXYZABCDEFGHIJKLMNOPQ
QRSTUVWXYZABCDEFGHIJKLMNOP
PQRSTUVWXYZABCDEFGHIJKLMNO
OPQRSTUVWXYZABCDEFGHIJKLMN
NOPQRSTUVWXYZABCDEFGHIJKLM
MNOPQRSTUVWXYZABCDEFGHIJKL
LMNOPQRSTUVWXYZABCDEFGHIJK
KLMNOPQRSTUVWXYZABCDEFGHIJ
JKLMNOPQRSTUVWXYZABCDEFGHI
IJKLMNOPQRSTUVWXYZABCDEFGH
HIJKLMNOPQRSTUVWXYZABCDEFG
GHIJKLMNOPQRSTUVWXYZABCDEF
```

10th Copy 20th Copy

30th Copy 40th Copy 50th Copy

Arlene Schloss

"The Alphabet"

1976, Xerox 6500 Color Copier, 50 sheets, each 8½" × 11".

Pictured here are the results of putting the copy of each successive copy of the original image through the copier a total of fifty times. Each box represents ten generations of copies. Notice how after twenty generations the alphabet takes on the characteristics of another civilization.

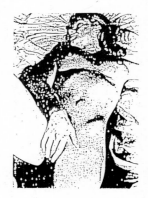

THE DEGENERATIVE PROCESS

One of the easiest and most effective *Copy Art* techniques is to make copies of copies of copies. You can use either the black and white or color copier and the results can be startling. After several generations or runs through the machine, the original image will start to "break-up", losing definition and forming a pattern all its own.

For each machine, you will find that the "break-up" will take on unique characteristics. It's as if the machine were stretching and expanding the image, tearing down the original boundries and coming up with an Impressionistic work that often resembles a woodcut.

Artists Ed Seman and Arlene Schloss have utilized this technique by running through as many as one hundred generations. As you can see, the end product is sometimes totally unrecognizable from the original. Does the machine have a creative soul of its own? One begins to wonder.

Ed Seeman

"Woman Holding Her Own"

1977, Xerox 3100 LDC, 4 Prints, 5″ × 7½″.

"While I was playing with the Xerox copier, I noticed that repeated duping of black and white photographs created a textured picture. At first I merely succeeded in producing an interestingly textured piece of art that resembled either a charcoal drawing or, in some cases, a woodcut. I found that I could control the shape of the texture as well as the subject matter by alternating the direction that the artwork was fed into the machine.

Further experimentation brought about the conclusion that the more rich blacks and hot whites produced in the first "dupe", the greater retention of black and white. Instead of stretching the grey areas into textures, the machine would stretch the blacks and create "holes" as well as create dots in the hot white areas. The result was a new hard-edged set of patterns that vibrated with "OP-ART" intensity.

The copy machine has provided another tool where the machine's accidents merge with the artist's control to create un-predetermined art."

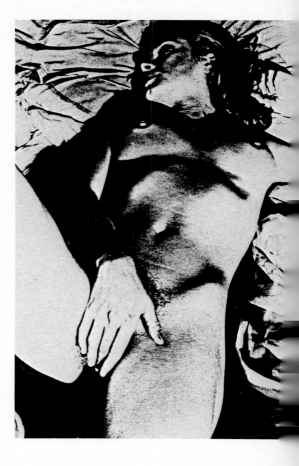

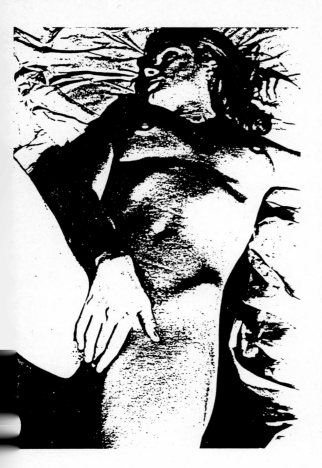 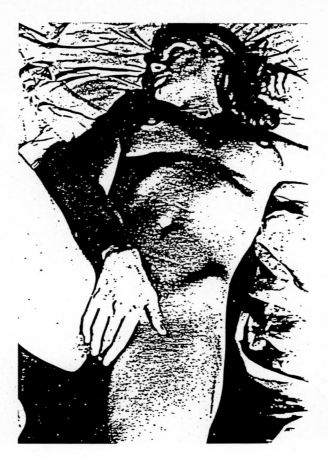

Patrick Young

"Birth Announcement"

1978, Black and White Xerox, 8" × 9½".

Patrick Young used the color Xerox machine to create this unique announcement of his son's birth.

COPY ART CARDS

You might say that *Copy Art* cards are for when you care enough to *make* the very best! There's something very special about receiving a card that someone has taken the time to put together themselves and something very satisfying about actually making one. With the cost of your average, store-bought card hovering somewhere between fifty cents and a dollar, it's cheaper in most cases to invest in a trip down to the local copy shop and do it yourself.

The making of a personalized card draws upon many of the basic *Copy Art* techniques. Feel free to combine any of them to produce the kind of card that works best for you. To get you started, here are some easy guidelines.

Try to do as much work as possible on your card *before* arriving at the copy shop. The ideal way of dealing with the copy shop is to have the card completely set up on a plain sheet of paper which they can then copy with no fuss. You then take your copies home, cut them to size, and rubber cement them onto thick card stock.

You can save on copying costs by laying out the same original design several times on one sheet of paper or cardboard. If your design cannot be reproduced by hand, an alternative is to make as good a copy of it as possible, lay out the copy and the original on the same sheet, and then make copies of that sheet. The trade-off is a loss of quality on the copy of the copy.

Large letters, designs, old letter heads and cards, magazine clippings and photographs can first be reduced on a black and white copier with reduction capabilities. You can then add color to this reduced black and white image by running it through the color copier. Old black and white photographs can also be given a beautiful tint on the color copier.

Using the SUPERIMPOSITION technique, you can "float" your message over either a snapshot or a slide image. If you make your card from a slide, the zoom lens on the slide projector will let you zoom in on any section of the slide. Another interesting combination of techniques is to use real objects to mask your photographs or slide images.

In conclusion—*Copy Art* cards are among the simplest, most satisfying, and economically sensible uses of copying machines that we have come across. Try an easy one the next time you have the occasion to send out cards. We think you will be hooked.

Gerry Miller

"An Actual Postcard"

1978, Color Xerox Collage, 4" × 6".

"My postcards have been generated by images I've found, by labels off tin cans, by posters, newspapers, stamps and stickers. I've used color Xerox for its gutsy, all-or-nothing flavor and mailed these postcards to friends and acquaintances with a sincere desire to brighten their mailboxes and convince them that not everything is a bill. I've had a lot of fun sending these postcards and quite often have had beautiful and extraordinary responses as well."

Johanna Vanderbeek decided to place real fruit and vegetables on the Color Xerox machine to create instant menus for her restaurant.

(Photo by Claudia Katayanagi)

georgette's

APPETIZERS

Cold soup of the day.............................1.50
Smoked eel with red onion rings and capers......2.00
Clam soup with six clams steamed in tomatoes....2.50

ENTRES
with green salad, baked or boiled potatoes, and vegetable

Vegetable special................................6.50

Broiled fish of the day..........................6.50

Filet of beef with horse radish sauce...........7.50

Rock Cornish Hen stuffed with granola, smoked
 oysters, and water chestnuts.............7.50

Poached fish in Port wine sauce.................7.50

Steamed Chinese Fish garnished with mushrooms,
 onions, hot pickles, raisins.............7.50

Gingered Shrimp- shrimp stir fried with fresh
 ginger; garnished with scallions and
 pickled ginger..........................8.00

Hot and Spicy Duck with lichee nuts and
 kumquats.................................8.00

Lobster- pound and a half lobster..............12.50

DESSERTS

Lemon pie chilled with whipped cream topping....1.50

Mocha cream pie with walnut pastry..............1.50

Whole wheat chocolate cake......................1.50

Fresh fruit with spiced honey...................1.50

BEVERAGES

Lapsong Souchang or herb tea.....................50

Coffee served with half and half................50

Rose Avery

"He had left home and wandered . . ."

1978, Collage, Colored Pencils and Color Xerox, 5" × 7½".

Rose Avery uses collage, cut-outs, and colored pencils to create a distinctive and imaginative card.

"I think that the debris, *effluvia* and trash of our civilization should be preserved, and I attempt to do so in my collages. 'By their trash shall ye know them'."

he had left home and wandered

Cigar boxes covered with colored images using the 6500 color copier by Patrick Firpo.

Vida Hackman

"White Tiger, Black Warrior"

1977, Black and White Etchings, Color Xerox Mounted in Book Form, 7″ Diameter.

"Original Etchings"

This book was created from Color Xerox images of 35mm slides of Vida's original etchings. The images were printed on Arches, Murillo and Japanese papers.

The images are from slides of current work—a four part series of etchings printed on white and black backgrounds.

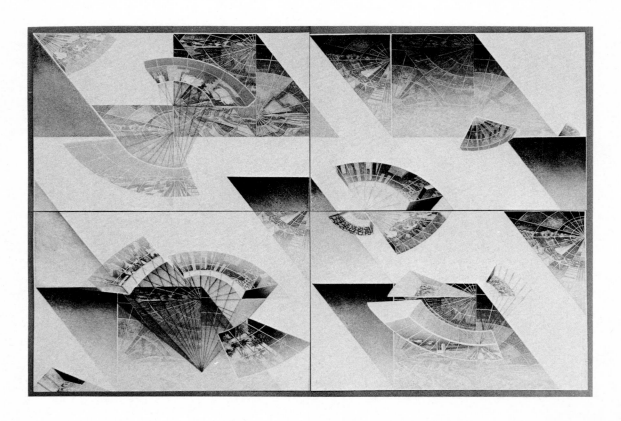

L. John Harris

"The Lloyd J. Harris Animal Boxes"

1969, Photobooth, Collage on Black and White Xerox Mounted on Card,
4 Boxes, 1½" × 2¼"; 1 box 3½" × 5".

L. John Harris of Berkeley, California created a series of
animal boxes in response to a personal and artistic crises.
"The identification with animals evoked a primitive self
experience and the packaging of the self was both a spoof
on advertising and a transcendental identity process.
Changing my name to Lloyd after an apple pie
manufacturer and packaging my new identity was
magical and an ideal vehicle for self-transformation."

COPY BOXES

From ancient gourds, to teakwood boxes, to bejeweled caskets, to the "copy
box", creating beautifully personalized containers can bring one a wealth of
satisfaction. In its most basic form, the "copy box" can be a cigar box covered
in some textured wonder created on the magic copy machines. With the
copier's ability to copy things such as wood grain, leaves, flowers, marble
patterns, and fabric patterns directly, the possibilities become endless.

Armed with an idea, some material suitable for copying, a pair of scissors,
and some glue, you can transform an ordinary box or cannister into something
that says, "I did this myself." Pictured here are a few approaches to the "copy
box".

31 JUST PASSING THROUGH

42 WAVE OF BLISS

46 ABUNDANCE

30 CASTLES IN THE CLOUDS

6 WISH-FULFILLING GEM

45 LIKE A BUBBLE

COLLAGES

"Our media culture bombards us with a barrage of man-made images—billboards, symbols for traffic movement, magazines, books, television with commercial interruption, etc. Unrelated images and concepts follow each other in rapid succession. This is especially true in major urban centers. Dreams and fantasy are also comprised of seemingly unrelated images and events and can be an ideal bank for the collage artist to draw from. Collage mimes these visual relationships by juxtaposing unrelated material within a given framework."

—Jeffrey Schrier

There are countless ways of assembling a collage. If you succumb to collage fever you will, undoubtedly, develop your own system through much trial and error. What we will do for you here is spell out a very basic beginner's method which you can expand upon later.

First determine which images you will be using. Lay out as many as you can fit on the document glass of the color copier trying to keep the color and black and white pictures separate.

Copy the color photographs in full color, making at least two copies of each batch of pictures. If you have the time, it's also useful to make another two copies, one in each of the machine's primary colors. Older black and white photographs can be transformed by copying them in a variety of primary colors. Once again, make at least two copies of each group of pictures.

Select a simple, uncluttered slide which you can use for the background. Clouds and water patterns work well. Use the matrix technique to create as large a background as you need. On a large piece of matte board, lay out and rubber cement down your background copies. They will create the basic frame for the collage.

Take a one-edged razor blade, matte knife or scissors, cut out the images you will be using. Play with them for a while to get a feeling for different ways in which they can be put together. "Layering" all the pictures into your own personal symmetry can be enormously gratifying so, give yourself plenty of time, get the right tools (rubber cement, rubber cement thinner or solvent so that you can change your mind), and have fun!

Your local camera shop can probably arrange to have the finished collage photographically reproduced if it's too large to be copied on the 6500. If not, color copies remove the traces of overlays and create a consistency of texture and unity which can be quite pleasing.

Penny Slinger, Nik Douglas and Meryl White

from *"The Secret Dakini Oracle"*

1977, Photo Collage, Each card 3″ × 5⅛″.

Penny Slinger, Nik Douglas and Meryl White have used collage in the creation of *"The Secret Dakini Oracle"*, a deck of divination cards. The cards are comprised of archetypal images drawn from Eastern mystical teachings in the Tantric tradition. The color Xerox machine was used as an intermediate step in the production and presentation of the cards. Published by U.S. Games Systems, Inc. Printed in full color by AG Muller and Cie.

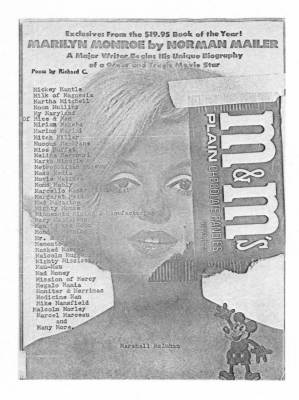

Richard C.

"M & M's"

1973, Mixed Media and Xerox Black and White, 8½″ × 11″.

Richard C. of North Carolina says he uses the copy machines found in local libraries to create many of his *Copy Art* works.

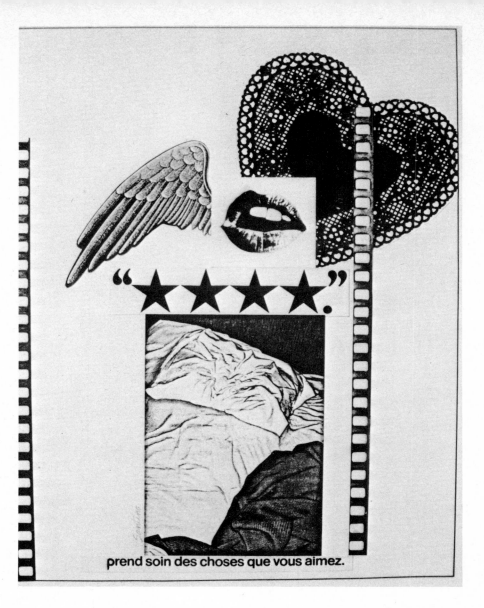

Richard Santino

"Prend Soin des Choses Que Vous Aimez"

1978, Collage & Black & White Xerox, 11½″ × 15″.

This illustration appeared in the February, 1978 issue of *Christopher Street* magazine.

Steven Fletcher

"The Gaga Board of Directors Interrogates the Muse at Headquarters"

1977, Collage, Acetate Overlays and Color Xerox in Book Form, 8½" × 11".

"For me, the collage method using acetate overlays affords time-economical image composition and variations that can be related to animation cells. People and objects move in and out of the space. Paintings shift back and forth across the walls. Props appear and disappear simply by adding and subtracting overlays."

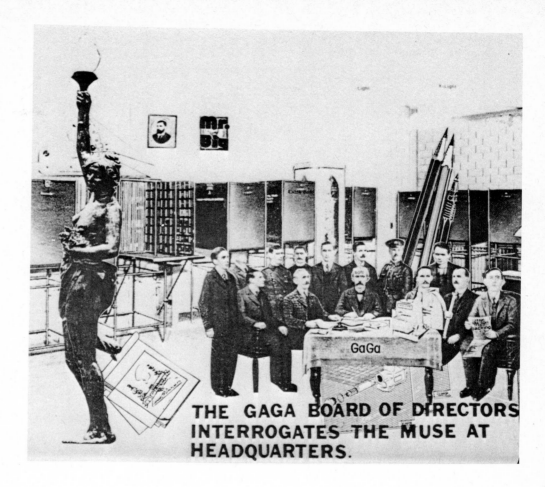

Acetate Overlay

ONE
RED
NIGHT

Aviva Rahmani

"6 I Ching Answers: 1975-6"

1976, Drawings, Black and White
and Color Xerox, 7" × 9½".

Rachel Rosenthal

"Petit-Beurre"

1976, Typewriter and
Color Xerox, 8½" × 4½".

Aviva Rahmani

"One Red Night"

1977, Limited Edition Book—Color Xerox, 7½" × 7".

"This is a series of Xerox prints from slides taken at regular intervals last summer recording the color changes in one sunset. Neither the slides nor the color printing were distorted. The slides, however, were Ektachrome and printed without a filter. The range is from orange to magenta. After printing them, they were simply cropped and mounted and made into this book."

THE HOME PRESS— PRINTING LIMITED EDITIONS

As more and more people asked us to use our color copier to publish limited editions of their work, we realized that we had a unique home press at our disposal. Until now, the high cost of color separations has kept most everyone except the major book publishers from printing in color. The technology of the instant color copier, however, brings color printing home.

Because plain paper copiers will accept virtually any type of blank paper, you can do your "printing" on extremely fine quality stock. As this book goes to press, we are assembling a limited xerographic edition of one of William Burrough's notebooks for a Swiss publisher.

We have seen some imaginative books and folios that were created by using the heat transfer process. The individual pages are reproduced onto heat transfers instead of conventional paper. The heat transfers are then ironed onto a very fine quality artist's lithograph or serigraph paper with results that look quite elegant and costly.

Your finished folio can be bound in a variety of processes. Many stationary stores and copy shops have installed simple binding machines that can do an excellent job. Some copy artists have even had their pages laminated in thin sheets of clear plastic.

E F HIGGINS III

22478

☞ AIR MAIL COMMEMORATIVE DOO·DA POSTAGE WORKS © ⌶ẟ3

E. F. Higgins III

"Air Mail Commemorative"

1978, Color Xerox 6500, 8½″ × 11″.

Buster Cleveland

"Buster Post"

1978, Color Xerox 6500, 8½" × 11".

This series of stamps was created
by Buster Cleveland for
Cavellini on blue graph paper.

FANCY STAMPS

Ed Higgins is a purveyor of the MAIL ART school of correspondence. His DO DA
post office has created a series of limited edition stamps using the 6500
color copier. Ed loads the machine with gummed sheets (DRYVAC DRY GUM
60 pound paper—just like the real Post Office!) instead of regular paper and
out come beautiful stamps. Ed does include a US Post Office stamp on his
letters but they are sometimes a little hard to find surrounded by all the
imaginative and colorful reproductions of great events in the country of DO DA.

E. F. Higgins

"Subway Issue"

1978, Color Xerox Collage, 8½" × 11".

"I have been making postage stamps for a couple/three years now, collecting stamps as a child and carving erasers into rubber stamps when I was fourteen or fifteen. I have studied all forms of printmaking in school, working in a rubber stamp shop in Boulder, a Litho shop in Boston, and currently working with a 6500 color Xerox copier here in N.Y.C.

As I remember, Doo-Da comes from a line in a Stephen Foster song, "Camptown Races" and connotes to me happiness at working. Stephen Foster probably never picked cotton "all the live long day", so you better put that it comes from an old negro slave song. I am a slave art at times, with definite leanings towards becoming a Xerox junkie. I have been utilizing the Xerox 6500 Color Copier for printing stamps and assorted artworks. This facilitates creating numerous small run editions, with the possibility of sending color works to other artists."

Buster Cleveland

"Pop Art"

1978, Color Xerox Collage, 8½″ × 11″.

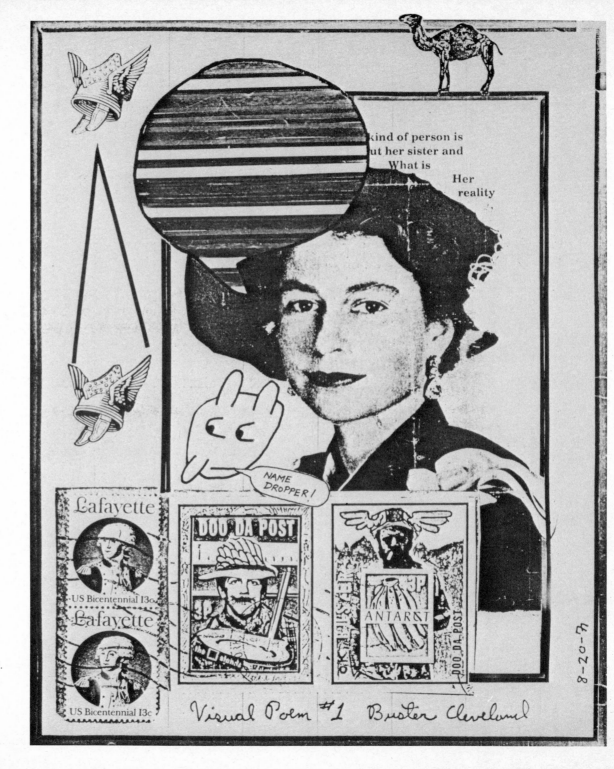

Buster Cleveland

"Visual Poem #1"

1978, Color Xerox and Collage, 8½″ × 11″.

Anna Banana

"Master of Bananology"

1977, Royal Bond Black and
White Copier, 8½" × 11".

MAIL ART

Ray Johnson, Ed Higgins, Anna Banana, Paulo Bruscky, R. Mutt, and
Cavellini are a few of the people actively involved in corresponding through
Mail Art. The Mail Art Movement is an international network of artists that uses
the postal system to exchange original compositions—usually on postcards,
letters and envelopes. In some cases, the recipient adds on to the original piece
and then mails it along to another artist—until the work finds itself back in the
mail box of the original sender (see *"Chess With Claudia Katayanagi"* by
Leonhard Frank Duch of Brazil).

Mail Art is usually a medium of multiple images, which is why so many mail
artists have utilized the instant copier.

CHESS WITH CLAUDIA KATAYANAGI

1

2

3

4

5

6

Leonhard Frank Duch *"Chess With Claudia Katayanagi"* 1978, Black and White Xerox, 9¼" × 12¾".

Richard Mutt

"Yours in Dada"

1978, Rubber Stamps, Color Xerox, 8½" × 11".

In memory of R. Mutt who died April 26, 1978 from his wife Grace Hopkins aka Tinkerbelle.

"R. Mutt's art works are concerned with the general conditions of man and the artificial environment. They most often address themselves to social change through politics, sex, and the middle class ethic. The artist's interpretation is manifested by juxtaposing visual and linguistic images to create puns.

Richard thought that art should be fun, exciting, and a forum for communication with people regardless of their specialized interests. He designed his art around his life and made it public."

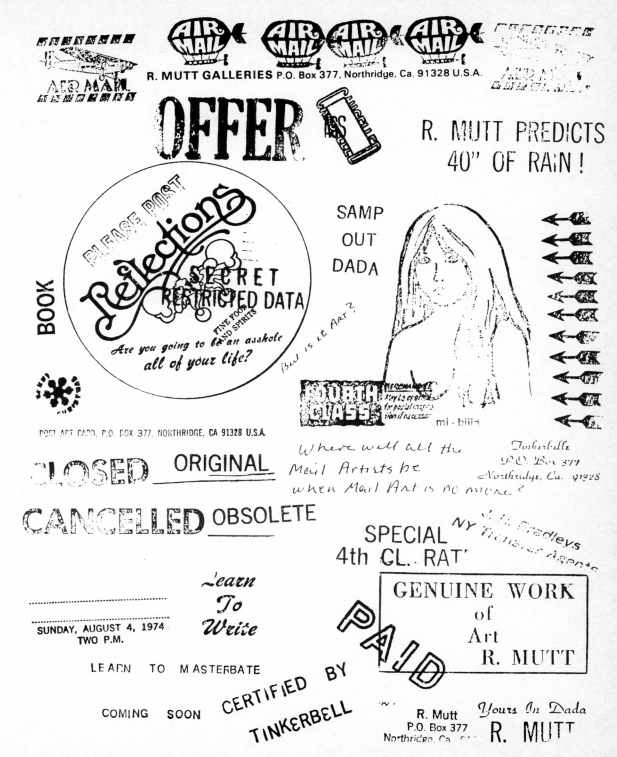

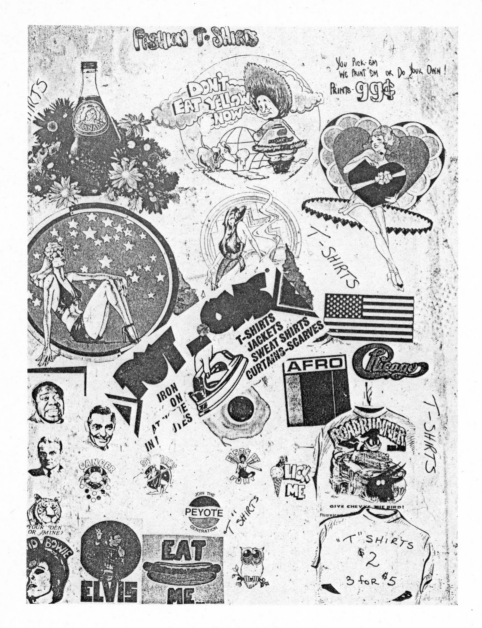

New York

London

Roy Colmer

From *"Found Objects in New York City, London and Hamburg"*

1975, Black and White and Color Xerox, 8½″ × 11″.

Objects that were picked up from the streets of 3 cities over a period of 1 week in each city and copied, some in black and white and others in color. The Xerox sheets were originally bound into three volumes, one for each city, and in a limited edition.

Hamburg

CREATING VISUAL DIARIES

Roy Colmer has created several works which represent visual records of objects found in the course of a week in different cities. He takes these objects, places them directly onto the machine, and makes copies of them which he then inserts into a notebook.

They are a rather unique and interesting way of getting to know a city. Leafing through these diaries, one gets a sense of the city by the objects it throws away.

Artist Vida Freeman applied the concept of visual diaries to taking a picture of herself every day for a year, making copies of these pictures, and then inserting the copies into a book called, aptly enough, "The Three Hundred and Sixty Four Days". Her photographs were shot in black and white, a contact sheet was made and then reduced on the Xerox 3107 black and white copier.

Vida is currently working on another concept called "Construction Sites and Empty Lots" which also uses the black and white reduction copier. This concept documents land use in Northridge, a suburb of Los Angeles. The project involves taking photographs of construction sites and empty lots over a three year period. Coupled with old maps of the area, it will show the influence of building and construction and become a visual record of the changing environment.

Jan. 1, 1977

Jan. 2, 1977

Jan. 3, 19

Jan. 5, 1977

Jan. 6, 1977

Vida Freeman

"Three Hundred and Sixty Four Days: A Photograph Daily Journal"

1977, Photographs, Reduced and Copied on the Xerox 3107, 8½" × 11".

"Starting in July, 1976 I took a picture of myself each for one year, using a 4" × 5" camera. I did not follo theme or preconceive the photograph prior to shooting . . . I merely took what I felt like taking at moment.

I embarked on the project for two reasons. First, I w to develop some concept of my own body and the it takes up. Secondly, I wanted to make the opport to spend at least the time necessary to take a pictur myself to pay attention, if briefly, to my feelings and body. I forgot to take a photograph on only one da though a few photographs were ruined during exp or development.

The experience was worth the time and effort!"

ANIMATION WITH THE COLOR COPIER

Eduardo Darino

A Frame from Film "Hello".

Eduardo Darino, a New York animator and teacher, has used various copy machines in conjunction with his animated films. He has taken advantage of the reduction, blow-up, and color control facilities of the copier to develop a unique process that allows the animator to control speed, shape, size, movement, and colors in various combinations.

Ed can add color to any black and white film. Split screens, wipes, burn-in titles, and other visual effects are possible in one single production step, avoiding high contrast loops, optical printing and other costly processes.

"We have shot directly off the mirror inside the 6500, and also used the paper copy output to assemble animation cells. We have also fed 16mm film into the copier by adapting its slide adapter and adding a ¼CT blue 203 Lee filter to improve projection.

We shoot with a 35mm Bell and Howell camera with Oxberry animation motor and control box, or a 16mm Bolex with a JK animation motor. We sometimes combine slide projection with objects resting on the document glass of the copier. For film stock, we've settled on Kodak 7252, processed normally, and shot without filters."

Ed adds a few pointers for those interested in applying the color copier to animation:

● Avoid too much contrast, specially when copying color originals, slides, or 16mm reversal film.

● Graphically colored originals are ideal artwork; still photos, transparencies, overhead projection masters and copies of first-generation art will reproduce well, too.

● Hand painted originals do not reproduce well.

● Cells, glasses, magnifiers, screens, tints and almost any other optical or visual aid can help you modify and improve your images.

● You may lose image quality trying to control background tones; decide in advance what concessions you are willing to make.

● Keep in mind that copies of second generation originals lose contrast, detail and definition.

● Watch out for slight enlargement on the copier: we have developed a registration guide to help us here. Most of all, experiment, experiment!

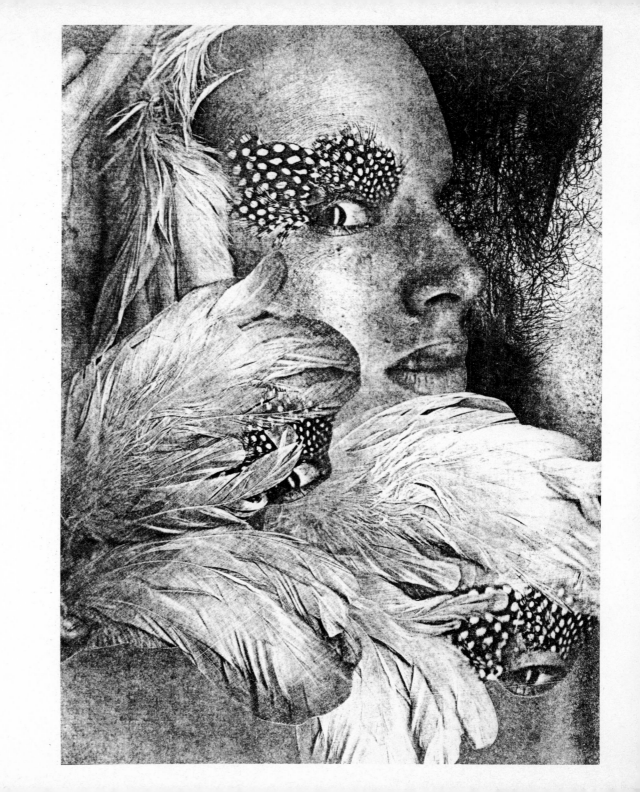

Penny Slinger

"Flirting Feathers"

1977, Black and White Xerox and Collage, 8" × 10".

BODY ART

By placing various parts of the body on the copy machine, you can utilize it as a camera. Many artists, have created full body copies on the copier. Almost everyone who has been left alone with a copier has experimented with making copies of their face and hands. In our own experimentation, we have come up with certain guidelines which will help you get better results from your own "body art".

The first thing to be careful of is extraneous movement, especially on the color copier. Unless you are absolutely still, color copies of your body will be blurred. One of our more interesting experiments came as a result of deliberately moving in between the scans. By leaving one side of your face down on the document glass for one scan and then turning around to catch the other side for the next two scans, your final result will be an eerie two-faced image. (See Patrick Firpo's *"Look Both Ways Before You Cross"* in the color art section.)

Better results are also achieved when you use a cloth over your head to prevent extraneous light from reaching the machine. Depth of field varies from machine to machine so, unless you're looking for a deliberately distorted result, be careful about squishing yourself up against the document glass. Noses have a special tendency to look a bit flat on first copies of the face!

If you are using a 6500 color copier, interesting results can also be obtained by using the slide projector and the backlighting technique to create a high-contrast color silhouette. This is achieved by moving slightly after each of the three color scans. Be sure, however, that the plastic lens assembly used for copying slides is on the document glass. Otherwise, you will get a burn-out on your copy. Body Art can also be created onto heat transfers which, in turn, can be applied to almost anything.

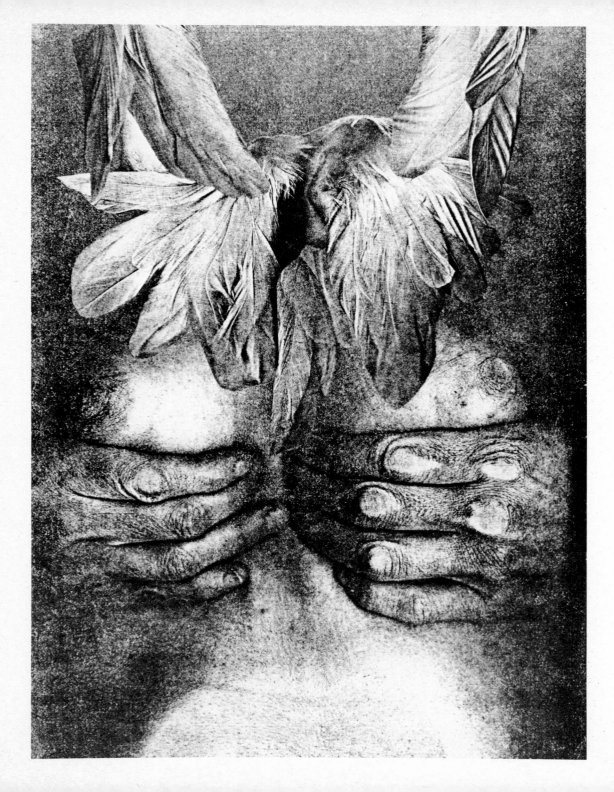

Penny Slinger

"Feather Breasted"

1977, Black and White Xerox and Collage, 8″ × 10″.

From a triptych, with the third image in the series appearing in the Black and White Art Section of this book.

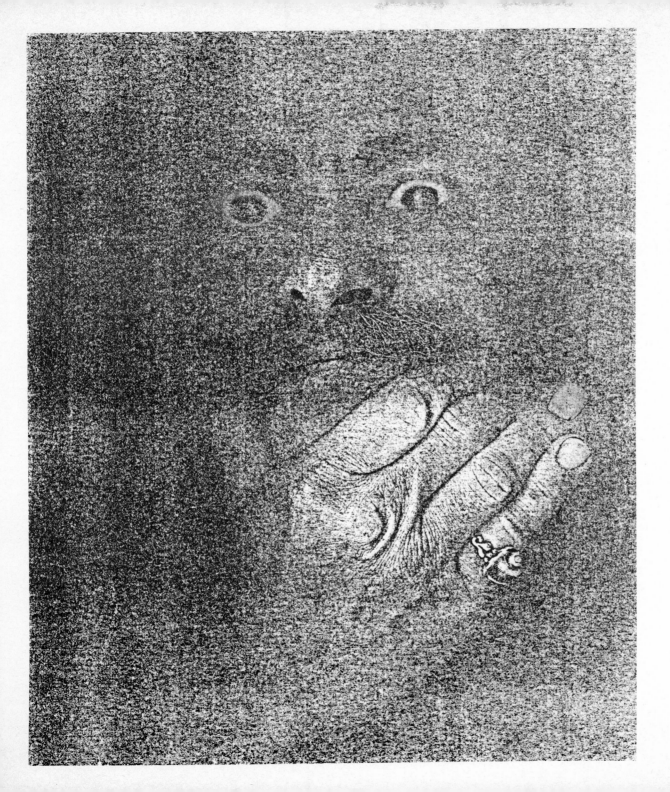

Payson Stevens

"Amused Appreciation"

1978, Black and White Xerox 4100, 8½″ × 11″.

From a series of 6 "mood portraits" taken from a larger self-published work called "Instant Art".

"Part of the intrigue for me is concerned with the element of distortion and what appears to be some limbo space-time between when light and electrons interact and then when the pigment is laid down. I view *Copy Art* as a form of technological redirection in overcoming machine alienation."

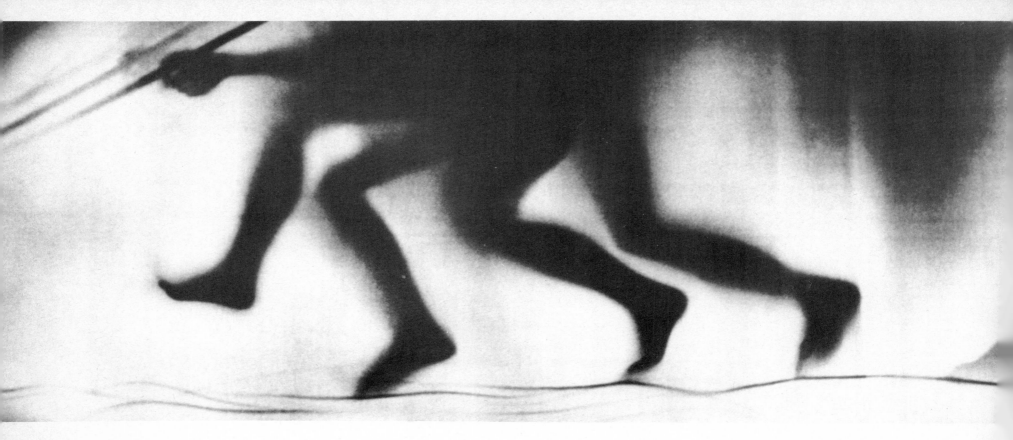

Steven Mendelson

"Aerialist in Motion"

1977, Actinic Light Source
on Ozalid (Blueprint) Paper,
12′ × 31′.

"Actinographs are merely shadows
of 'actions' and therefore, subject to
imagination. What really happened
in time and space to leave these
sensual impressions moving across
the soft-hued murals of our minds?"

Mary Dougherty

"Handmade Yony"

1977, 3M Variable Quality Copier I, 8½″ × 14″.

A woman's hand (Mary Dougherty) and a man's hand
(Mitchell Petchenik) engaged in a dialogue on a 3M VQC
machine. The hands were surrounded by leaves and
covered with a white cloth. Neither person could see what
the other person's hand was doing and there was no
verbal communication between the participants. On
signal they would rearrange their hands and push the
print button. The twenty resulting images told a story and
were compiled into book form.

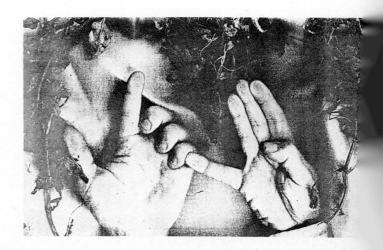

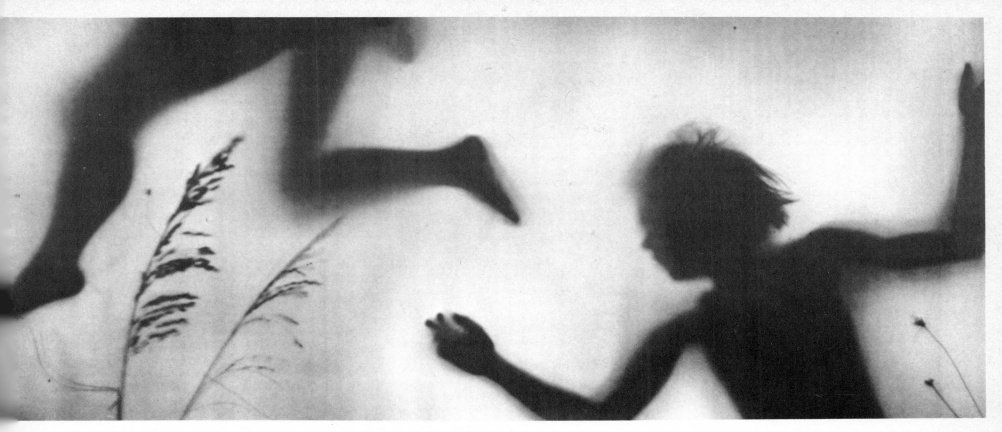

Steven Mendelson *"Youthful Folly"* 1977, Objects and Live Models With Actinic Light Source on Ozalid Paper, 3' × 7'.

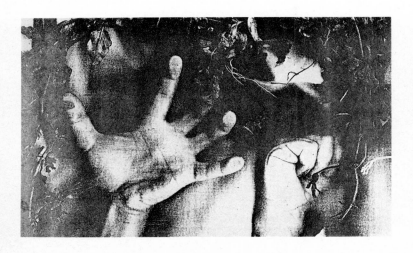
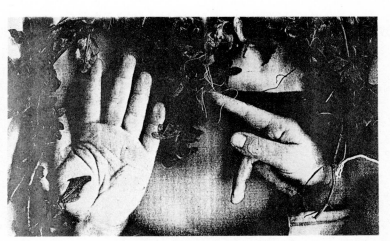

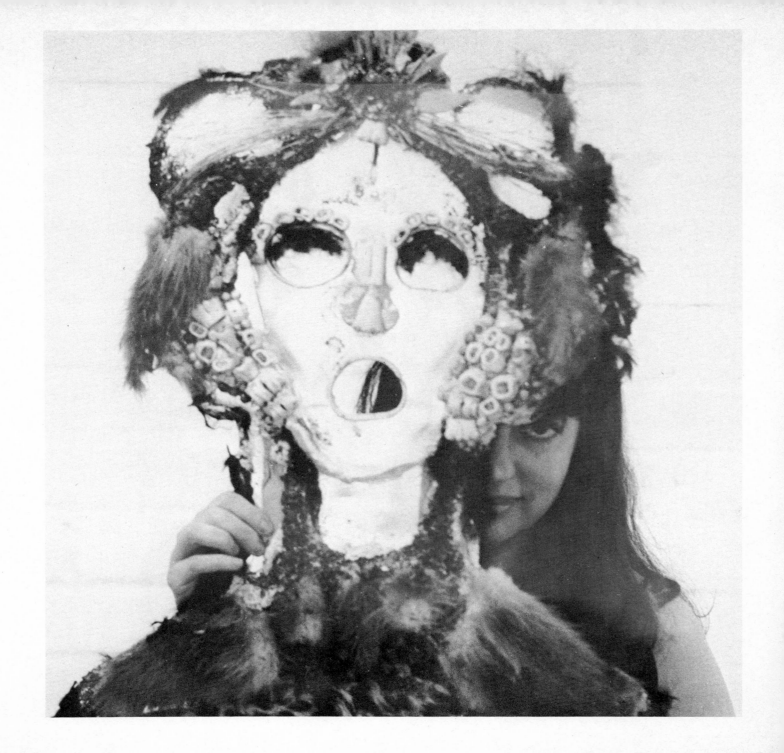

MASKS

Suzanne Horvitz has applied her talents to the fabrication of *Copy Art* masks. Using cut-outs from magazines, rhinestones, bits of glass, and pieces of bone, she creates primitive and evocative "Death Masks". Most of Suzanne's masks were created using both the black and white and color copiers. She says that it amuses her that the masks have such a primitive quality to them and yet have been created on a twenty-first century business tool.

The unique ability of copy machines to make direct reproductions of virtually any image lends itself perfectly to mask making. On a very practical level, you are no longer obliged to go out and purchase ready-made Halloween masks. With the copy machine and a little imagination, you can create your own. A few photos from some magazines, some rubber cement, a pair of scissors, and a trip to the local copy center add up to a fun and productive afternoon for you and your children.

Suzanne Horvitz

"Death Mask"

1977, Collage of Minolta, Savin, IBM and Xerox Black and White Prints, 8½" × 11".

uzanne Horvitz *(left)*

Sue Horvitz Holds Her Self-Portrait Mask" (Photo by lan Goldstein)

76, Minolta Electrographic 101, Savin 770, IBM II, Litton Royal Bond, rox 3100, Collage, 8½" × 11".

Paul Bridgewater

"Paper Forest" (Photo by Barbra Walz)

1978, Savin 770 Black and White,

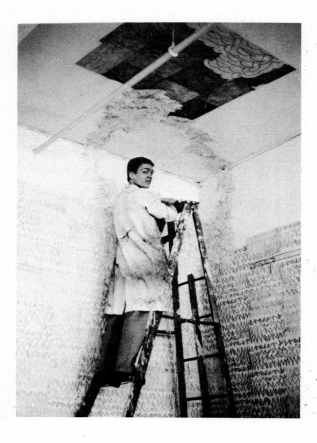

Paul Bridgwater's *"Paper Forest"*, 1978. Created on the Savin copier. *(Photo by Robert Carpenter)*

Tyler Hoare

"Classic"

1977, Color Xerox with Mirror on Formica Base, 11″ × 17″ × 3″.

PAPER SCULPTURE

Yet another application of the copy machine is in the creation of paper sculptures. Paul Bridgewater decided that his white walls needed to be enhanced and created a "paper forest" using the Savin black and white copy machine and magic markers. He assembled the "forest" from 15 individual component drawings. Each drawing represented a different aspect of the forest—grass, leaves, flowers, etc.

After making multiple copies of each drawing, he randomly colored them in with magic markers. The sheets were then applied to the walls and floor in a pattern most representational of nature.

There are many variations on this theme. Real grass and plants may be copied on black and white machines and then colored in. Where the price is not prohibitive, flowers and plants can be copied directly on the color machines and assembled in a similar fashion.

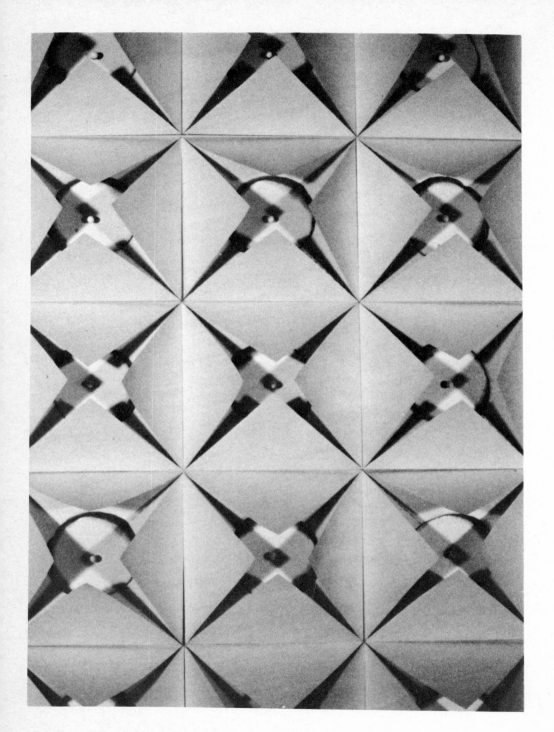

Mary Ann Becker

"9 × 9 = 81", Front View

1977, Folded Savin Copies and White Tacks, Each Square Copy: 5 and 11/16", Total Size: 61½" × 61½".

Mary Ann Becker uses a SAVIN coin-operated black and white copier and Origami (Japanese paper folding) as a means of achieving three dimensional paper sculptures. Her large format pieces use both the matrixing technique and multiples and are a unique blend of ancient and futuristic forms. These copies were achieved by placing clay discs directly on the machine.

"9 × 9 = 81", Detail.

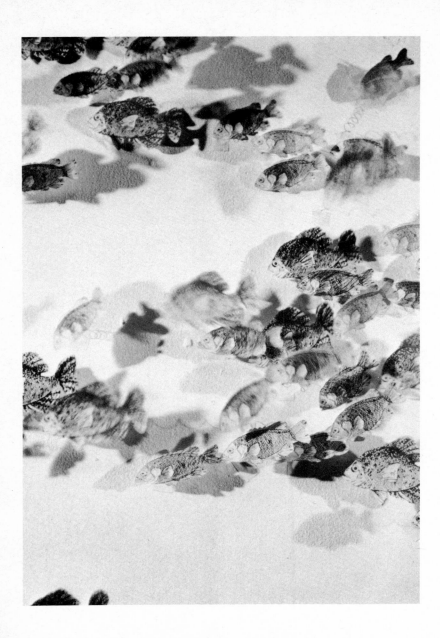

Ann Gillen

"In Praise of Autumnal Butterflies!"

1973, IBM Black and White Copier, 7½" × 6½".

Ann Gillen places folded pieces of paper directly on the machine and copies them to create beautiful sculptural effects.

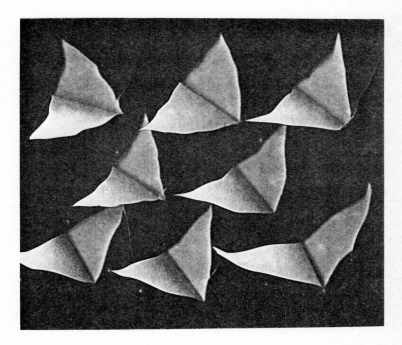

Christy Rupp

"Fish in Residence"

1977, Paper, Wire, Colored Pencils and Black and White Xerox, 20' × 40'.

Christy Rupp created a kinetic wall sculpture by making 400 copies of fish on a black and white xerox copier cutting up the copies and coloring them in by hand, and then mounting them on springs fastened to the wall in the shape of a school of fish.

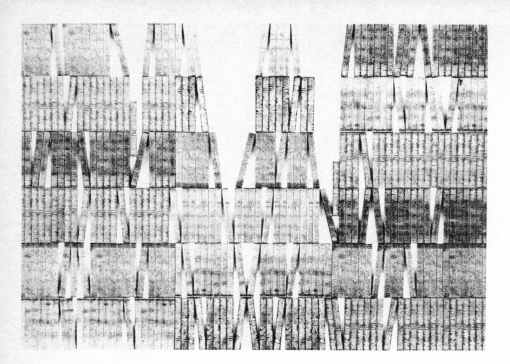

Robert Rossiter

"Untitled"

1976, IBM copies on BFK paper, 60″ × 80″.

PAPER MURALS

Artist Bob Rossiter has gone beyond the standard 8½″ × 14″ format to create larger pieces of *Copy Art*. Using a black and white copier and the principle of multiples, he has created a wall mural measuring 5 feet by 6½ feet. The multiples consist of IBM black and white copies of wood strips which are cut out from letter size copies and fastened to a large (60″ × 80″) white board on stiff backed paper.

Bob then draws over the full size drawing with pencil to enhance the textural quality of the wood. This also helps eliminate the lines between the copies and creates a unified look. This same technique can be used with other wood grain textures, marble patterns, tree bark, and book backings to create a library effect on your wall. Bob is currently working on a brick wall. He is even copying the plug outlets!

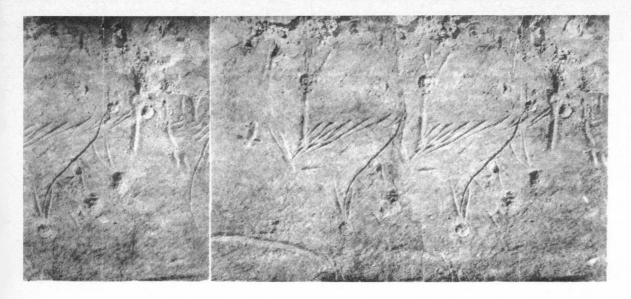

Charlotte Brown

"A Dialogue With Color" Detail

1976, 3M Color-in-Color Copier on Tiles, each tile 6″ × 6″.

"As a painter making prints after my own paintings, I wish to experience the relationship between art and the machine. I have created a body of work, printed on hand-crafted clay tiles and tablets. I have programmed some fifteen hundred color computer cards into the 3M Color-in-Color machine and have developed a process which now enables me to transfer images to a variety of clay surfaces.

My art has more the look of natural formations than that of a machine product. My imagery speaks of close-up views of earth, sand and stone surfaces with some archeological cave-like markings."

TILES

Charlotte Brown, a painter who turned to ceramics in an effort to get closer to the texture of her work, discovered a way in which she could convert her paintings into tiles with a little help from the 3-M Color-In-Color copier. Taking a standard unglazed tile (the particular brand that Charlotte uses is made by the H & R Johnson Company of England), she coats it with the 3-M photographic solution.

She then runs her drawings, or parts of her paintings, through the 3-M machine and onto heat transfer material. She applies the heat transfer to the solution-covered tile with an iron and the results are spectacular. The 3-M process differs from Xerox in that with 3-M you must place a photographic solution onto your medium before you can apply the heat transfer.

With color Xerox heat transfers, you simply iron on the transfer paper directly. Though Xerox has the edge in terms of convenience, artists who have worked with both machines agree that the 3-M system is far superior in terms of both quality and control. Several artists have been quoted as saying that the difference between 3-M and Xerox is the difference between fine art and commercial art.

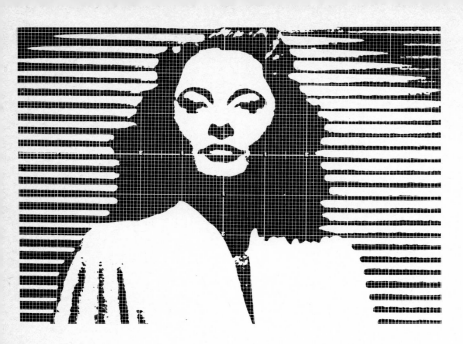

Jim Shaw

Untitled

1974, Whiteprint Machine, 8½″ × 11″.

Payson Stevens

"Five Portraits Traveling Thru the Ether" (opposite)

1978, Drawing on Mylar and GAF 930D Whiteprint (Diazo) Mach...
14″ × 36″.

Herbert Edwards

"X-Ray of Fish"

1976, Cyanotype (Blueprint), 9″ × 12″.

This is a cyanotype, which is sometimes known as a blueprint. It was made by exposing an X-ray of a fish onto cloth that was sensitized by a mixture of ferric ammonium citrate and potassium ferricyanide. The light source was ultraviolet.

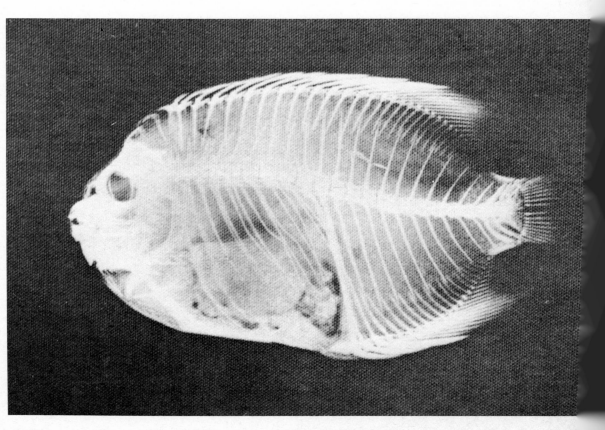

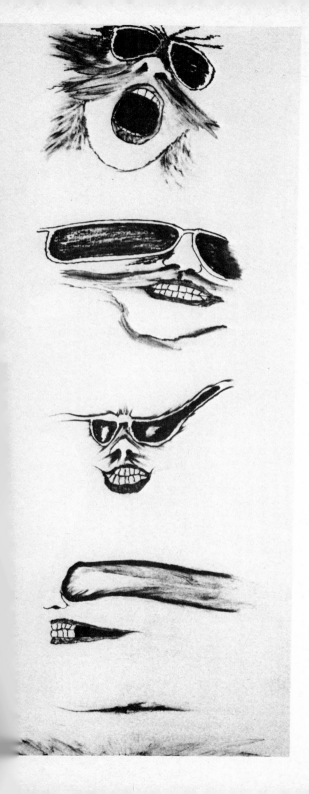

BLUEPRINT AND WHITEPRINT MACHINES

Blueprint and whiteprint (diazo) machines are found in most architectural, interior design, manufacturing and engineering offices. While these machines may not be accessible to most people, they do have a major advantage over conventional electrostatic copiers in producing much larger prints. Most diazo machines produce copies up to 42 inches wide and lengths of up to three hundred yards.

Many blueprint machines are being replaced by the whiteprint, or diazo machines. Two reasons cited by manufacturers for this are ease of reading and convenience of use. Blueprint machines, which produce a copy with a white line on a blue, black, brown or sepia background, require an ammonia solution to be prepared and then drained from the machine daily.

Several diazo manufacturers have developed a no odor, no heat whiteprinter with a disposable developing cartridge. Finished diazo prints can be blackline, blueline or sepia on white stock or, if color coding is desired, on various tinted stocks. Diazo copies can also be printed on translucent and opaque papers and cloth. If the machine is equipped with a mercury vapor light, copies can be made on acetate transparencies of up to forty two inches. Other materials, such as clear and matte films or mylar, can be passed through the machine with the original for special effects.

Most small diazo machines yield about ten copies per minute with hand-feeding of originals and paper. Larger, fully automatic production models can produce about fifty copies per minute, with widths of up to 54 inches.

Diazo copies are relatively inexpensive. Prices range from three cents per square foot for an in-house machine and from fifteen to forty cents per square foot for outside "blueprint" contractors.

Of the three examples in this section, "X-Ray of Fish" by Herb Edwards is a blueprint, while the pieces by both Jim Shaw and Payson Stevens are whiteprints, or diazo prints.

Steven Mendelson of McKeesport, Pennsylvania has coined the term "actinograph" for his whiteprint pieces. (See "Modesty" in the black and white Art Section, and "Aerialist in Motion" and "Youthful Folly" in the Body Art Section.) Actinic light sources, such as sunlight, sunlamps, or mercury vapor arc lamps contain the necessary ultraviolet rays to develop the light-sensitive paper, for both blueprints and whiteprints.

Patrick Firpo

"Lamp"

1978, Color Xerox Heat Transfers on Rice Paper, 9½″ × 15″.

This lamp was created by printing the images directly on the heat transfer paper and then ironing them onto the rice paper. The paper was then glued into the wooden frame.

A similar lamp can be made by fixing acetate transparency prints *directly* onto either glass or Plexiglass, mylar or canvas, to name but a few materials.

(Carpentry by John Arakawa)

Patrick Firpo

"Needlepoint Pattern"

1978, Color Xerox Heat Transfer on Needlepoint Canvas, 8½″ × 11″.

Patrick Firpo

"Shoji Screen"

1978, Color Xerox Heat Transfers on Rice Paper, 32″ × 67″.

The images on this screen were taken from a Japanese woodcut book and were first printed on an acetate transparency. The transparency allowed for the flopping or matrixing of the images in a repeat pattern onto heat transfer paper. The images were then ironed on rice paper and fitted into this shoji screen.

USING HEAT TRANSFERS

The fascination of heat transfers is that they can be applied to so many different surfaces. Through heat transfers, *Copy Art* can merge with countless other home crafts. We realized very early on in our own experimentation that a large part of *Copy Art* is simply ways of bringing something new to techniques and hobbies that many of you already know. Rather than attempting a summary of the countless crafts that *Copy Art* is applicable to, we have chosen to list some of the more interesting uses that we have seen. Make a heat transfer and apply it to something easy the first time out. Try a white T-shirt, for example, with a bright, colorful, and easily reproduced image. Then let your imagination wander.

For best results applying heat transfers to material, use permanent press materials made of 50 per cent cotton and 50 per cent polyester (100 percent cotton materials do not hold color after repeated washings). Place a protective cover of plain bond paper over the ironing board. This will prevent excess ink from the transfer staining the board cover or subsequent items to be ironed.

Place your transfer *design down* on the area of the material you wish to apply it to and pin it so it doesn't move while you iron. Place another piece of plain bond paper over the transfer to protect your iron. Set the iron to the "Cotton" temperature and, after it heats up, iron across the transfer firmly and evenly for approximately one minute.

There are two different schools on the best way to remove your transfer from material. The first method calls for letting the material cool for at least one minute and then slowly removing the paper. The second method recommends lifting up the paper while it's still hot. With this method, you can see where the ink has not properly "taken" to the fabric. When that happens, go back over the area again with your iron. Lift the transfer off very slowly and evenly.

No special laundering is required. The colors will fade slightly but, if you have applied your transfer correctly, they won't fade out. Do not use chlorine bleach on permanent press materials.

Try Heat Transfers on:

T-shirts	Needlepoint	Room Dividers
Jeans	Dolls	Tiles
Vests	Stuffed Animals	Limited Editions
Pillows	Furniture	Fine Art Prints
Quilts	Wood Surfaces	Wallpaper
	Lamp Shades	

Patricia Worrell

"*Punk Poet*", from the Collection "*Objects of Affection*".

1978, Color Xerox Heat Transfer on Handmade Doll, 8″ × 24″.

(Photo by Claudia Katayanagi)

PERSONAL RECORDS

How many times have you reached into your pocket or purse and discovered that the whole world contained in your wallet has disappeared? One excellent use of almost any copy machine you can get your hands on is to keep a record of your credit cards, driver's license, social security card, passport, checkbook, personal telephone and address book, and all the other documents that are necessary for life in the twentieth century.

Just lay out everything to be copied on the document glass of the machine, press the button, and file away the copy in a safe place. When copying an address or telephone directory, it's usually easiest to make one copy for each spread (2 pages) of the actual book. If your book happens to be oversized, try copying it on a black and white machine with reduction capabilities.

LIGHT PAINTINGS AND OTHER TECHNIQUES

1) The first technique is a way of copying objects and "suspending" them in a sea of color. Place the objects on the document glass of the 6500 color copier. As the machine scans each color, lift the document covering lid in varying degrees—anywhere from three to eight inches.

The scan light will reflect off the white inside cover and produce a shaded, colored, background effect in each of the three basic colors. By using the contrast control, you will be able to achieve some outstanding pastel colorations. Remember that the contrast control doesn't work when the document cover is held all the way open. You will find interesting applications for this technique whenever a colored background is called for.

2) This technique consists of using the plastic lens assembly as an actual lens. Place objects onto the document glass and turn on the slide projector with no slide in it. You are now using the slide projector to backlight your objects. Hold the plastic lens over the objects and move it while the machine completes its three scans. The motion should be either toward or away from the objects on the document glass. This technique can also produce some beautifully colored backgrounds.

NOTE: Remember to use the plastic lens assembly whenever the slide projector is on or you will see a burn-out on your copy.

3) For this technique, place the plastic lens assembly directly on the document glass and turn on the slide projector so that it back lights directly onto the plastic lens. Place objects or cut-outs on the plastic lens. If you keep the objects still and move them quickly in between scans, you will get beautiful tri-color "ghost" images or color separations. Moving them during the scans will produce COPY MOTION effects.

4) Some of the nicest results we have achieved have come from moving our hands in sweeping motions over the light bar as it makes its scans. This "hand dance" in conjunction with backlighting can produce beautiful colors and patterns.

Objects such as jewelry and cut-glass produce their own special reflective patterns but, the truth of the matter is that almost any object placed on the

machine can be manipulated to create fascinating copies. It is really the closest thing there is to electronic action painting and the magic is in never really knowing what your efforts will produce until the machine delivers the final product into your hands.

5) This technique is a little more complicated and of use to you only if you happen to be left alone with a 6500 color copier. The machine is designed not to operate when the two side panel doors reserved for the "key operator" are open. You can bypass the automatic shutoff device by placing two four-inch bar magnets where the top of the door would normally make contact with the machine.

As the machine completes its last scan, remove the bar magnet that completes the circuit nearest to where the copy counters are located. This will stop the machine and prevent the sheet of paper from entering the tone fusing tray. Because the colors are still in a powdered form, they can be easily manipulated.

Take a brush or your finger and move the powders around to create a textured effect. When you've got what you want, re-insert the paper into the fusing tray, replace the magnet, and permanently set your colors. With a little practice and luck, you'll get a beautiful fresco effect.

Using the same process described in number three, remove the image before it reaches the fusing tray. Place the unfused color copy directly onto the document glass, run through a couple of generations, shake well and serve piping hot. (See Patrick Firpo's "Hands" in the color art section.)

By combining these two techniques, you can convert any black and white portions of a slide image to color at the same time. Select a mixed color for the black parts of the image. Press the color selection buttons for the two primary colors that will produce this mixed color. For example, press the magenta and yellow buttons if you wish the black areas to reproduce as red.

Determine which of these two primary colors you wish to substitute for the white parts of your image. In the case of the mixed color red, you have the choice of either magenta or yellow.

Place your hand in front of the projector during the scan which prints the color you want for the white areas. If the mixed color selected was blue, block the filters during either the first (magenta) or third (cyan) scans. The black areas of your copy will reproduce as the mixed color (blue) and the white areas will reproduce as the primary color (magenta or cyan). (See Patrick Firpo's "Lumins" and "Hand Dance V" in the Color Art Section.)

TELECOPIERS

"A Telecopier encodes visual information in sound and sends it by telephone to another Telecopier which decodes the audible information back into visual form and prints it on a paper which is usually carbon-based. Information can be sent in varying times, usually 3, 4, or 6 minutes. The image is made by straight lines on paper, usually measuring 8½" × 11", which is placed against a revolving drum and imaged by a spark from a stylus or by a process involving a metallic silver bar.

The Telecopier is a fantastic, quick, elegant imaging machine. I like its straight lines as they define curved spaces, the ability to overlayer, stretch images, edit and shift the axis of the original image. What I don't like about the carbon-based papers is the way the flying carbon can mess up your lungs. Always work in a well-ventilated area or wear a damp surgical mask for protection.

My favorite machine is the 3-M Remote Facsimile Machine because its blacks seem richer than that of the Xerox Telecopier 400. The Stewart Warner Datafax makes a fantastic dark brown image out of silver on translucent white paper. The paper can be used as a photographic negative for contact prints. The limitation of this machine is that you cannot edit your image.

Telecopiers are made to be linked by telephones. You can bypass the actual calling by obtaining two old telephones and connecting them to a 12-volt battery. Or you can use one machine and connect it to a microphone connected to a tape recorder. Small, portable recorders distort the image less than large, complex ones. Once the image is recorded onto a cassette, it can be played back into the Telecopier by means of a small speaker. The speaker (no bigger than 2" in diameter) is placed in the telephone coupler.

If you transmit an image at 4 minutes and receive it in 6 minutes, the image will be compressed. And vice-versa. For maximum blacks and tonal detail, the tip of the stylus must be free of residue and it must rest against the drum with the correct amount of pressure. Several people have experimented with using synthesizers to modulate Telecopier sounds and therefore image patterns." (See "Cliche-Verre Brassai" by Peter Thompson.)

Peter Hunt Thompson

Print 8 from Unit 13

1977, Collage, Jump-edited Telecopier prints, 8½" × 11".

Acknowledgements

We would like to express our gratitude to the following people for taking the time to submit their work and thoughts for inclusion in this book. Many beautiful images could not be included because of space limitations.

Kathleen Agnoli, Benny Andrews, Peter Astrom, Joe Battle, John Baylin, Mary Bryan, Muriel Castani, Paul Collins, Richard Craven, Bill Doherty, Gary Ford, Kit Fitzgerald, Peter Fleishman, Franklin Furnace, David Freelander, Deborah Freedman, Nicole Gelpi, Tom Gormley, Denise Grunstein, Robert Gundlach, Valerie Hammond, Joel Handorff, Kirsten Hawthorne, Stephen Hazel, Dennis Hermanson, Douglas Holleley, Stu Horn, Tom Hosier, James Hugunin, Poppy Johnson, Sara Jones, Gerald Kaglovec, Cynthia Karasek, Piotr Kowalski, Michael Langenstein, Eve Laramee, Stephen Laub, Elise LeBovit, Ray Lopez, Richard McKown, Judy McWillie, Stephen Miller, Michael Mollett, George Moran, Museum of Modern Art (Janice Putney), New Museum (Marsha Tucker and Susan Logan), Holly O'Grady, Sue Osborn, John Overton, Frank Palaia, Marian Perry, Stanley Perring, Jonathan Price, Virginia Rolston, Jost Romero, David Root, Ira Rosen, Rachel Rosenthal, John Sanborn, Stephen Schneck, Martin Schrieber, John Schultz, Richard Skidmore, Keith Smith, Pauline Smith, Juliana Swatko, Joel Swartz, Paco Underhill, Jan Van Raay, Bob Wade, Peter Warren, Joan Weber, Mimi Weisbord, Selena Whitefeather, George Whiteside, and Stewart Wilson.

BIBLIOGRAPHY

"Art from Technology", Industry Week, October 12, 1970.

Cook, W. A. *Electrostatics in Reprography,* Focal Press, London-New York, 1970.

Dessaurer, John H. *My Years With Xerox: The Billions Nobody Wanted.* Manor Books, Inc. New York, 1971.

Dessaurer, John H. and Clark, H.E., editors. *Xerography and Related Processes,* Focal Press, London-New York, 1965.

Douglas, Cheryl, editor. *3 M Color: An Exhibition Organized by the Friends of Photography,* Carmel, California, 1973.

Flanagan, Barbara. "Instant Art on Copy Machines", The Minneapolis Star, January 5, 1971.

Floyd, Howard A. "Color Copiers: We Should Be Careful How We Use Them", *Reproductions, Reviews and Methods,* July, 1973.

Grey, Ben E. "Color Copiers: How Did We Ever Get Along Without Them?", *Reproductions, Reviews and Methods,* July, 1973.

Hayden, Harold. "Revolutions in Modern Printmaking", Chicago Sun Times, July, 1970.

Ruspoli-Rodriguez, Alexis. "Color-in-Color with Art", Popular Photography, January, 1974.

Schaffert, Roland. *Electrophotography,* Focal Press, London-New York, 1975.

Sheridan, Sonia Landy. *A Generative Retrospective,* University of Iowa Museum of Art Catalog, Iowa City, 1976.

Sheridan, Sonia Landy. "Energized Artscience", The Museum of Science and Industry, Chicago, 1978.

Sheridan, Sonia Landy. "Generative Systems", After-image, Chicago, April, 1972.

Sheridan, Sonia Landy. "Generative Systems", After-image, Chicago, March, 1975.

Thompson, Peter Hunt, editor. "Untitled 9", Friends of Photography, Carmel, California, 1975.